Barnet Libraries

- Please return by the latest date stamped below to avoid a charge
- You may renew by phone or post. Please quote number on the bar code label below
- May not be renewed if required by another reader

09. OCT 90

27. OCT 90

14. 11. 90

05. JAN 91.

23. FEB 91.

31. JUL 91.

10. NOV 92

20. JAN 93

20 Feb 93

15 JUN 93

L121 09. FEB 94

05. MAR 94

03. MAY 94

20. MAY 94

16 JUL 94

5 AUG

18. OCT 94

26. NOV 94

31 DEC 94

25. JAN 95

09. MAY 95

30. SEP 95

13. JAN 96

16. DEC 95

04. MAY 96

24. JU 9

25. SEP

31. DEC
18. MAR 9

09. APR 97

30

19. NOV

20. MAR

24. JUN

17. OCT

26. MAR 9

30. APR 99
22. OCT 99

03. 06. 00

19. APR 06.

0 6 OCT 2007

2 7 OCT 2007

2 4 JAN 2012

1 - MAY 2013

BRUEGEL

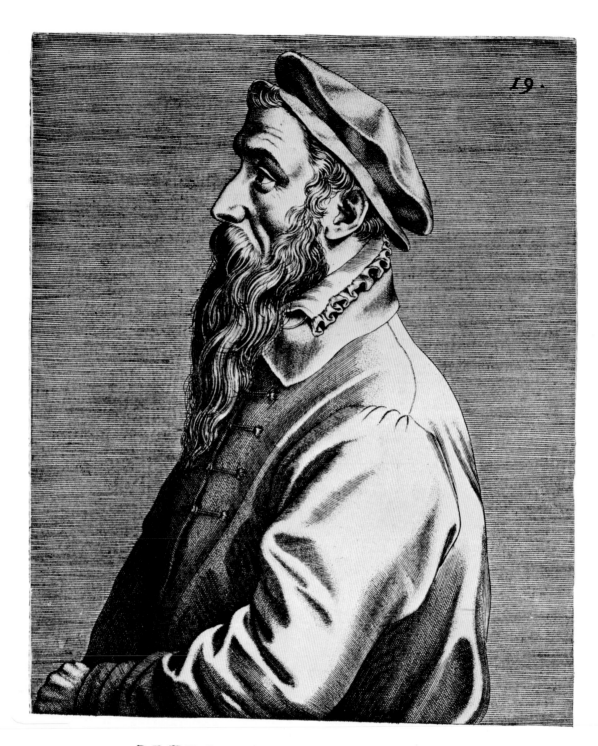

PETRO BRVEGEL, PICTORI.

Quis nouus hic Hieronymus Orbi
Boschius? ingeniosa magistri
Somnia peniculoque, styloque
T anta imitarier arte peritus,
V t superet tamen interim & illum?

Macte animo, Petre, mactus vt arte.
Namque tuo, veterisque magistri.
Ridiculo, salibusque referto
In graphices genere inclyta laudum
Præmia vbique, & ab omnibus vllo

Artifice haud leuiora mereris.

PIETER
BRUEGEL

THE ELDER

TEXT BY

WOLFGANG STECHOW

THAMES AND HUDSON

Frontispiece

Portrait of Pieter Bruegel.
Engraving from Dominicus Lampsonius,
Pictorum aliquot celebrium Germaniae inferioris effigies.
Antwerp, 1572

The passage from the poem "Musée des Beaux Arts" has been
reprinted from *Collected Shorter Poems 1927–1957* by W. H. Auden
by permission of Random House, Inc. Copyright © 1940 and
renewed 1968 by W. H. Auden.

Originally published by Harry N. Abrams, Inc., New York

First published in Great Britain in 1990
by Thames and Hudson Ltd, London

This is a concise edition of Wolfgang Stechow's *Bruegel*,
originally published in 1970

Printed and bound in Japan

CONTENTS

PREFACE

In the introductory text, an attempt has been made to offer a view of Bruegel that combines a survey of the scanty documentary evidence concerning his life and art with the inevitably subjective interpretation of those of his works which have stood the test of time and of vigorous criticism; drawings and prints have here been consulted *pari passu* with the paintings, for reasons that I hope will become obvious to the reader. In the commentaries to the colorplates, all paintings that in my opinion can be given to Bruegel with certainty, or at least with a high degree of confidence, have been discussed somewhat more fully from the viewpoint of both content and form.

This book owes an overwhelming debt to the scholarly efforts of others. In 1604, Van Mander wrote that "there are few works by [Bruegel's] hand which the observer can contemplate solemnly and with a straight face. However stiff, morose, or surly he may be, he cannot help chuckling or at any rate smiling." This view is still echoed in Gustav Glück's important contributions to a fuller understanding of Bruegel's art, and Max J. Friedländer said of the master's later paintings that they "set out on the road to an ethically neutral genre picture," not without adding the devastating thought that "as far as Bruegel is concerned, he was less clever than his interpreters, but their superior as to sense of humor." These views of Bruegel were time-bound; so must, by necessity, be the ones presented here which, understandably, deal with a "darker" Bruegel. They owe a considerable debt to the studies of Carl Gustaf Stridbeck, but try to avoid the latter's unmistakable elements of rigidity, and in this respect, they follow the lead of Fritz Grossmann, to whom I am greatly indebted, both for his published work and for advice *in litteris*. A Bruegel seminar given at Vassar College in 1966, and lectures given at Williams College and Smith College, have served as gratefully remembered opportunities to formulate the views presented in this book.

W. S.

Oberlin, Ohio

BRVEGEL

It is a truism that every epoch has its own conception of a great artist of the past. What Shakespeare meant to the reader or spectator of his own time, and again to the reader and spectator of the eighteenth century, differs significantly from what he means to us; our image of Mozart may share few features with the image that the people of 1780 and even of 1880 had of him. It is easy to understand why this should be so; and we also know that artists were sometimes totally, or almost totally, forgotten during long periods and then rediscovered by artlovers of epochs to whom their work appealed again because of a special kinship of aims.

In the case of Pieter Bruegel yet another aspect of discrepancy between "their" and "our" artist is of great importance. Here we have to do not only with two different interpretations of the same works, but also with two different kinds of work. The Bruegel best known today is the great *painter* Bruegel. This is as it should be, and one can defend the thesis that

the democratization of the work of Pieter Bruegel as a painter is one of the towering achievements of the age of color photography. However, it is necessary to realize that these works were not accessible to most of his contemporaries or even much later. The role which modern photography plays in reproducing masterpieces was formerly played by reproductive prints, and one might think that such reproductions of Bruegel's paintings existed during the artist's lifetime and made them just as popular then as they are today, although in much less reliable reproductions. This did happen in the case of other painters, but it simply is not true of Bruegel. Engraved reproductions of his paintings were not available then, with few exceptions. The paintings were much sought after but most of them were made for, or almost immediately snapped up by, collectors who felt little responsibility for making them accessible to others in any way; and this situation continued for a long time. The few engravings after Bruegel's

Figure 1. Anonymous engraver after Hieronymus Bosch.
THE LAST JUDGMENT. c. 1550–60.
Engraving, 9½×19¼″

paintings that were made in the sixteenth century were almost all done by men who worked after the master's early death in 1569. Incomparable masterpieces of his brush such as the famous series of the "Months" now in Vienna, New York, and Prague (colorplates 20–25), were probably entirely unknown even to the comparatively initiated of Bruegel's time, and even of later generations; the same is true of the great allegories and genre pictures which everyone knows today. Instead, contemporaries of Bruegel were deeply impressed by prints which were made from those of his designs with which he deliberately turned to larger audiences. In addition to what Bruegel wanted to give to the patrons of his brush, there was a good deal that he wanted to say to the man in the street, exactly as Dürer had done two generations before—Dürer, who made his great paintings for a similar group of distinguished, or at least thoroughly knowledgeable, patrons, and who took his burin and, even more frequently, his woodcarver's knife when he turned to "the people."

However, this is not to say that Bruegel did not insert a good deal of the same didactic material into his paintings, even though this was done with greater reserve and in such a way as not to disturb the specific pictorial laws, and in particular, the laws of economy which developed with the years within this area of

his output. The study of his "popular" work has made us more aware of this element in Bruegel's art, and thus has had most beneficial results for our endeavor to understand more completely what the artist expressed in his paintings.

The unprecedented popularity of Bruegel's works in our time is the result of a strong feeling of kinship among the general public. Modern artists, too, have sometimes been impressed by Bruegel's treatment of human emotions and the mood of his figures and landscapes, but have on the whole shown little interest in Bruegel's *formal* means, and particularly, in his methods of composition. These are just as diversified as his views of man and nature. The works of the artist cover a span of no more than about sixteen years, but within this brief period he employed a variety of interpretation of subject matter and of formal devices which confront us with the phenomenon of the basic otherness of each of his works and of the most intricate interrelationship between structure and interpretation. To gain full access to this wealth of important aspects, let alone to sum it up briefly, is a well-nigh impossible task which makes one sympathize with the desperate comment of one of the most perspicacious Bruegel scholars, Fritz Grossmann: "The man has been thought to have been a peasant and a townsman, an orthodox catholic and a Libertine, a humanist, a laughing and a pessimist philosopher; the artist appeared as a follower of Bosch and a continuator of the Flemish tradition, the last of the Primitives, a Mannerist in contact with Italian art, an illustrator, a genre painter, a landscape artist, a realist, a painter consciously transforming reality and adapting it to his formal ideal— to sum up just a few opinions expressed by various observers in the course of four hundred years."

We know shockingly little about Bruegel's life and the conditions under which he began and developed his art and brought it to perfection within little more than one and one-half decades. Our main source remains the "Vita" which Carel van Mander dedicated to the artist in his *Schilder-Boeck*, first published in

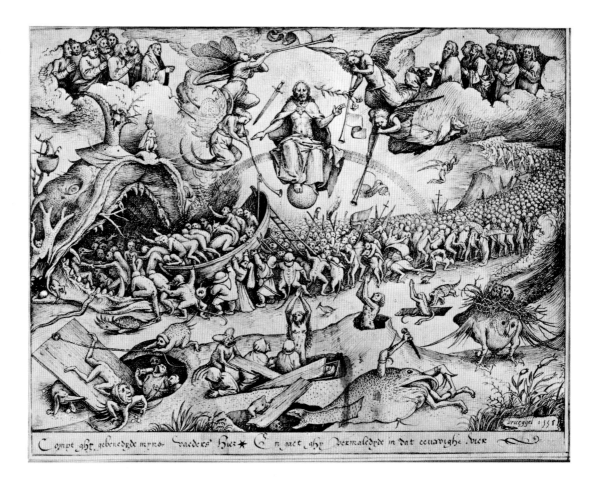

Figure 2. Bruegel.
THE LAST JUDGMENT.
1558.
Drawing, 9 × 11¾″.
Albertina, Vienna

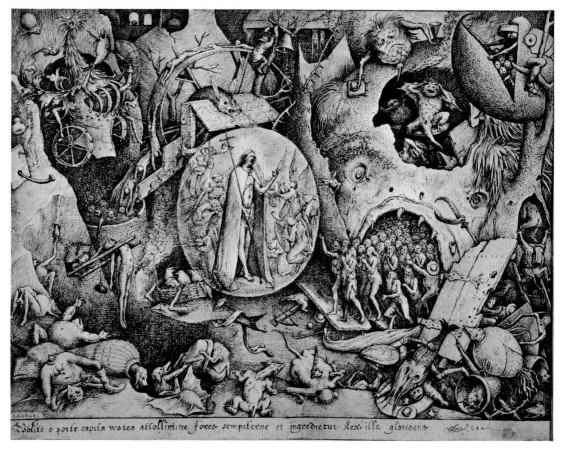

Figure 3. Bruegel.
CHRIST IN LIMBO. 1561
Drawing, 8¾ × 11½″.
Albertina, Vienna

II

1604; few documents have turned up since that time, and there is still much too much room for speculation in the absence of a fully reliable body of information.

Both the year and the place of his birth are in doubt. The name "Bruegel" (the artist's own spelling from about the year 1559) probably does not mean that he was born in a village or town thus called, of which there are at least two; rather, it appears to indicate a well-established family name. There were several other persons called Bruegel in Flanders about that time, and it may be worth mentioning that the form "*van* Bruegel" has never been employed. On the other hand, the form "Peeter Brueghels" does occur in the Antwerp guild entry and must be interpreted as Peeter, the *son* of Brueghel. Finally, one of the oldest writers on Bruegel, Lodovico Guicciardini, writing in 1567, called the artist "Pietro Brueghel di Breda." This important piece of information also makes it almost safe to say that he was a city, not a country, child. The date of his birth will probably never be established with any degree of certainty; about 1528–30 is as close as the new evidence to be discussed in a moment will let us get; in other words, he was probably no more than about forty years old when he died in 1569.

Van Mander says that Bruegel was a pupil of Pieter Coecke van Aelst, an important painter at Antwerp, but no documentary proof of such a relationship has come to light, and the slight stylistic bonds that connect the two artists can easily be explained on different grounds. The same author makes much of the nice tradition according to which Bruegel, while apprenticed to Pieter Coecke, often carried his future wife, Coecke's daughter Mayken, in his arms; but the whole theory of that apprenticeship rests on a very shaky basis. A recent discovery is apt to diminish our faith in it, or at least in the importance of such an apprenticeship, even more. We now know (from a document) that by 1550, Bruegel was working in the shop of one Claude Dorizi at Mechelen (Malines). In that year, Dorizi and his co-workers undertook to paint an altarpiece for the guild of the glovemakers. It was destined for the church of Saint Rombout in Mechelen and was to be completed on October 11, 1551; Bruegel was to work on the wings only, whereas the center part was to be painted by Pieter Balten

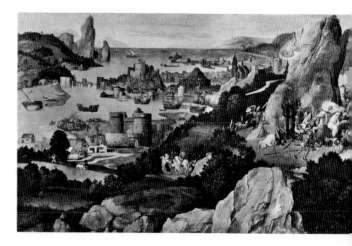

Figure 4. Joachim Patinir.
LANDSCAPE WITH THE MARTYRDOM OF SAINT CATHERINE. c. 1510–15. Panel, 10½ × 17⅜".
Kunsthistorisches Museum, Vienna

(or Baltens), who had become a master in the Antwerp painters' guild as early as 1540. While this new source leaves us free to assume that Bruegel came to Mechelen after an apprenticeship with Pieter Coecke van Aelst (who died in December, 1550), it also points to Bruegel's having had to work in a rather subordinate role as late as 1550; in addition to that, it underlines his having received some training at a center of the craft of painting in watercolor on linen, a technique in which he was to excel later in his career (fig. 60; colorplates 35, 36), so much so in fact that some scholars had already stipulated some connection with Mechelen for Bruegel long before the discovery of that document. Unfortunately, this altarpiece has disappeared, and our knowledge concerning Pieter Baltens' early career is practically nil.

Bruegel did become a master in the Antwerp guild of painters in 1551, the year of the completion—if it *was* completed—of the Mechelen altarpiece, and must therefore have had some standing in Antwerp before that time; but he was not to stay there very long, and it is even probable that he left for the South immediately after having joined the Antwerp guild.

Italy was the goal of nearly every Netherlandish painter of some ambition and promise at that time; we do not have to look for any special reason that compelled (the apparently still very young) Pieter Bruegel to join that trend, and we know in fact that the young Maerten de Vos (born in 1531/32), who

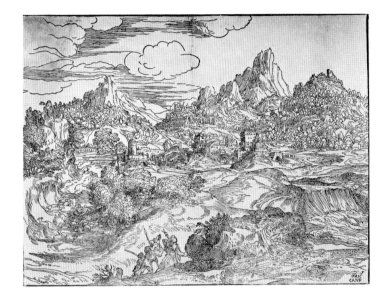

Figure 5. Domenico Campagnola.
LANDSCAPE. C. 1520.
Woodcut, 13½×18″

Figure 6. Bruegel.
LANDSCAPE WITH RIVER AND MOUNTAINS.
1553. Drawing, 8¾×13¼″.
British Museum, London

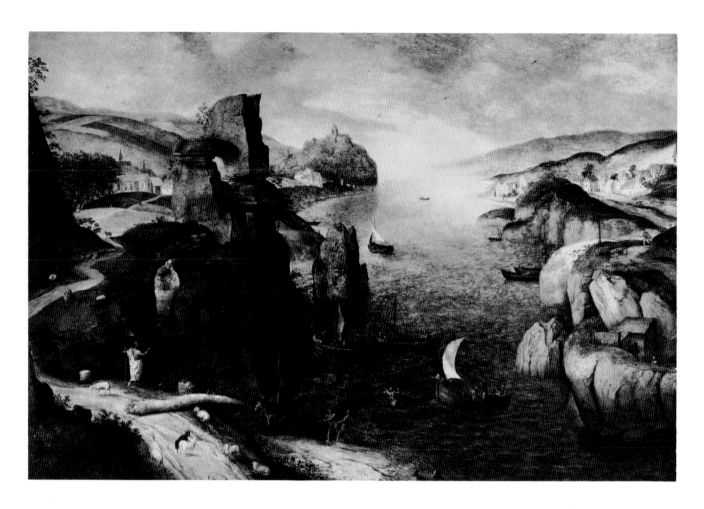

Figure 7. Bruegel.
LANDSCAPE WITH CHRIST APPEARING
TO THE APOSTLES AT THE SEA OF TIBERIAS.
Signed and dated 1553. Panel, 27×39¾".
Private collection, New York

was to become an important Antwerp painter and to be connected with some of Bruegel's later friends, was traveling in Italy at the same time as he. By 1552, Bruegel had passed through France (Lyons) and advanced as far south as Reggio di Calabria, a city set partly afire by an attack of the Turks in that year, and depicted burning in one of Bruegel's drawings. From there he crossed to nearby Messina (fig. 49), and probably visited Palermo. He also knew Naples intimately (colórplate 8). Two drawings with Italian motifs are dated 1552, and we are certain that in 1553 Bruegel was in Rome, where he continued to draw landscapes and may even have taken his first steps as an etcher; and here he acquired a friend and important patron of his early artistic activity in the much older miniature painter and scholar, Giulio

Clovio, with whom he occasionally collaborated, probably adding landscapes to Clovio's figure pieces. Bruegel's first large-scale landscape painting dates from that same year, 1553 (fig. 7); its larger figures are by a different hand (perhaps by Maerten de Vos), an indication of Bruegel's total dedication, at that time, to the art of landscape.

His itinerary on his way back home can be traced by means of some of his works; his fascination with grandiose scenery in the Alps led him to tarry longer in those parts and to jot down magnificent views of places in the Ticino Valley and near Waltensburg in the Grisons (fig. 23; situated northeast of the Saint Gotthard which he also represented in a lost painting once owned by Pieter Paul Rubens). From there he most probably went to Innsbruck before returning

to Antwerp, where he seems to have arrived in 1554. He took up close contact with the printmaker and publisher Hieronymus Cock, for whom he designed, beginning about 1555, a series of landscapes as well as many compositions with religious and didactic subjects, to be reproduced by professional printmakers. A large number of his original drawings for the figure subjects have been preserved; none of these enormously popular prints were made after *paintings* by Bruegel. The second of his known dated paintings is of 1557 (colorplate 1), and we are not certain that any undated ones can be placed prior to that. Thus, with the exception of the painting of 1553 (fig. 7), the entire known output of Bruegel as a painter may well have been produced in the eleven or twelve years between 1557 and 1568.

In 1563, Bruegel married Mayken, the daughter of his presumed first teacher, Pieter Coecke van Aelst. The wedding took place in Brussels about Easter; according to Van Mander, the artist had moved from Antwerp to Brussels upon the insistence of his mother-in-law, who was afraid that this move was the only way to make Bruegel forget his Antwerp servant girl friend. Whatever the motive, the removal from Antwerp must have been painful for more than one reason; he had close friends there, among them the famous geographer Abraham Ortelius (1527–1598). The depth of this great man's admiration for Bruegel as an artist can be gauged from the epitaph composed by him in Latin after the painter's premature death and inserted in his *Album Amicorum;* in it, conventional clichés gathered from ancient sources mingle with flashes of insight into Bruegel's real greatness as an incorruptible observer of nature. But Ortelius' friendship must have meant even more to Bruegel because it was most probably he who introduced the painter to a circle of Erasmian Catholics who courageously opposed orthodox intolerance toward critics of the Church as well as of the State, and not only preached but lived lives of humility, tolerance, and forthright moral courage, for which some of them paid dearly. A reflection of Bruegel's dedication to such principles can be found in Van Mander's statement that he had some of his drawings with "biting and sharp inscriptions burnt by his wife when he was on his deathbed, from remorse or [we might add: much more probably] for fear that she might get into trouble and might

have to answer for them." But more important, the plea for humility and tolerance is indeed one of the most decisive facets of Bruegel's printed work, and also an important ingredient of the content of some of his paintings, as will be pointed out later in greater detail.

But while Bruegel had to leave Ortelius and other friends behind in Antwerp—at least as far as *daily* communication was concerned—he did acquire new patrons in Brussels; they included Cardinal de Granvelle, Archbishop of Mechelen, confidant of Philip II, and a great collector, who owned several works by Bruegel, among which the superb *Landscape with the Flight into Egypt* of 1563 (fig. 8) seems to be the only surviving example. Commissions from Antwerp continued; by far the most important of these was the series of "Months" (most probably twelve paintings) which he painted for the great Antwerp mansion of Niclaes Jonghelinck (1565; colorplates 20–25). Finally, the City Council of Brussels seems to have asked him to paint one or several pieces representing the digging of the newly inaugurated (1565) Brussels–Antwerp Canal. The artist's death on September 9, 1569, appears to have prevented him from completing this commission, the subject of which could almost be called a symbol of Bruegel's position in Flemish painting as concentrated in the two great cities, and in midway Mechelen.

Much has been said about the very difficult problem of the formation of Bruegel's style, the "influences" that contributed to the emergence of his own vision of man and of nature. It will be remembered that much doubt has been voiced regarding Van Mander's statement that he was an apprentice of Pieter Coecke van Aelst; and even if this undocumented tradition should turn out to be true, the *art* of Van Aelst seems to have made little if any impression on the young Bruegel. His connection with the workshop of Claude Dorizi (1517–1561/65) in Mechelen, so recently proved by documents, certainly brought him in touch with a long tradition of painting in watercolor on canvas; but owing to the extreme vulnerability of such works, too little is known either about that Mechelen tradi-

tion or about Bruegel's own work in that technique to draw conclusions other than the fact of technical conformity. Unless and until Bruegel's wings of the Mechelen altarpiece of 1550 (which may have been painted in *grisailles*) are rediscovered—and who knows whether we would recognize them by their style?— the whole pre-Italian output of Bruegel must be considered a moot case. A connection with the art of Pieter Baltens, with whom he collaborated in 1550, has become a bit more probable but by no means certain. Nor can we tell much about his relationship to Giulio Clovio, whose work he seems to have supplemented rather than emulated. In essence, Italy meant landscape drawing to the young Bruegel—and this had never happened before to a Flemish artist. Only

much later was Italian figure painting to become a significant factor in his art.

With regard to the paintings made after 1553, and specifically after 1557 (when the compact series of preserved dated pictures begins), a number of important influences have often been commented upon. The most obvious of these is the deep impact of the art of Hieronymus Bosch. For one of the earliest writers on Bruegel, Lodovico Guicciardini (1567), the painter was a second Bosch, and this estimate was often repeated, as for instance in the verses that appear below Lampsonius' portrait of Bruegel (see frontispiece). It is a notion based more on subject matter than on style, and more on prints than on paintings— the latter a restriction that was by no means limited

Figure 8. Bruegel. LANDSCAPE WITH THE FLIGHT INTO EGYPT. Signed and dated 1563. Panel, 14⅝ × 21⅞".
Collection Count Antoine Seilern, London

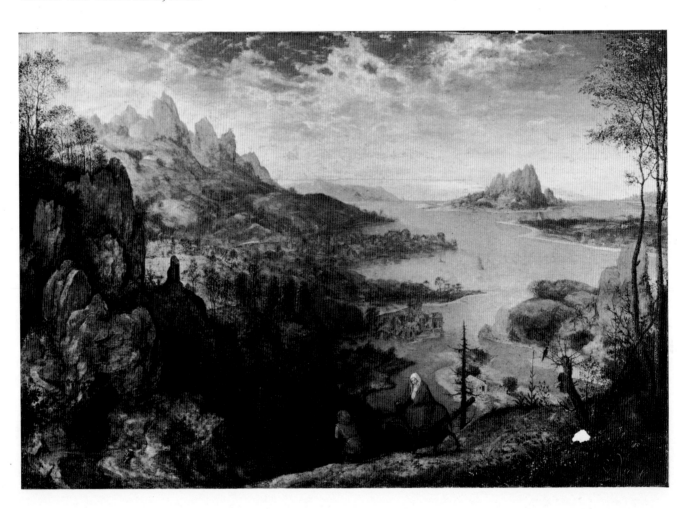

to Italian writers (including Vasari), seeing the inaccessibility of most of the artist's paintings even to Northerners. Among his paintings there are two in which Bosch's influence is indeed very strong: *The Fall of the Rebel Angels* (colorplate 9) and the *Mad Meg* (colorplate 10). These are by no means early works (they are both dated 1562), but they are undoubtedly in the Boschian tradition of superabundant fantasy and grotesque combinations of animal and human forms. There is no doubt that such pictures were considered, and avidly collected, as performances of a second Bosch in Bruegel's time, and although we would not mistake them for works by Bosch today, it is only fair to admit that many parts of the *Mad Meg* are almost indistinguishable from corresponding sections in some works by Bosch; however, the very concept of a mad Xanthippe raiding Hell victorious, and storming away to new conquests, is utterly unlike Bosch; furthermore, it must not be forgotten that this whole realm of phantasmagoria was only one facet of Bosch's art, even though a more important one than with Bruegel. In painting these two pictures, Bruegel briefly emulated (not imitated) that aspect of Bosch's art which made an undiminished appeal to a special group of patrons; he also paid his homage to Bosch (fig. 1) in several drawings made for reproduction in print, such as *The Last Judgment* of 1558 (fig. 2), and *Christ in Limbo* of 1561 (fig. 3). In addition, some drawings offer plausible evidence of Bruegel's careful study, after his return from Italy, of even earlier masters of the Netherlandish School, specifically Jan van Eyck and Dirk Bouts.

With regard to Bruegel's background and early development as a landscape painter, large question marks remain. Ever since Joachim Patinir (fig. 4) had raised landscape painting to a level of relative independence—and the restriction is important—artists and patrons had indulged in a predilection for vistas which provided a vast variety of natural forms in a kind of bird's-eye view which was actually independent of any considerations of scientific perspective, and more like a combination of a map come alive and an image of a never-never land exhibiting the greatest possible variety of interesting details. Even though each of these pictures still retained the semblance of a Biblical or mythological work, often with auxiliary scenes tucked away in nooks and cor-

ners of their vast recesses, the main interest of painters and collectors had clearly shifted from these events to their ambiance—an ambiance that in most cases had little to do with their historical setting, and, in fact, with any "possible" setting. By the time Bruegel went to Italy, artists like Herri met de Bles (figs. 57, 70), Cornelis Massys, and Lucas Gassel were the leading masters of that trend; Matthys Cock, whom we know as a draftsman only, had just died (1548). Undoubtedly Bruegel had studied their works attentively before he left for Italy, and he resumed his interest in them after his return; but his avid study of the Italian and the Alpine scenes had added an indelible ingredient to his art which placed his work in a category inaccessible to their efforts. He had also turned his attention—the attention of a draftsman, not a painter—to the way in which great Italian masters of landscape, including Titian and Campagnola (fig. 5), had seen and represented mountainous landscapes in their drawings and prints; his own landscape drawings of the Italian period (fig. 6), and even much later, show the results of that study more clearly than his paintings.

His earliest painting, the *Landscape with Christ Appearing to the Apostles at the Sea of Tiberias* of 1553 (fig. 7), does evoke the memory of earlier Flemish works; but it is the work of Patinir himself, rather than of his followers, that comes to mind, and this is still true to some extent of the *Landscape with the Parable of the Sower* of 1557 (colorplate 1). In at least one case, close connection with Patinir's traits has even led to the attribution to Bruegel of a picture by one of Patinir's close imitators. Evidently, Bruegel had by then found his way back to the more potent source of the efforts of his immediate predecessors, as far as the essentials of his landscape vision were concerned, including even its coloristic effects. There is a somewhat closer connection with masters like Herri met de Bles in some of Bruegel's later landscape paintings such as *The Suicide of Saul* of 1562 (colorplate 12) and *The Procession to Calvary* of 1564 (colorplate 16), although in the *Flight into Egypt* of 1563 (fig. 8) Patinir's heritage reasserted itself to some degree. However, already here, and certainly in the series of the "Months" of 1565, almost all reminiscences of the past phase of landscape art, including the Italian memories, have become rather irrelevant: what now

strikes us is the anticipation of Rubens rather than the echoes of Patinir's vision. As to the winter landscapes, the main inspiration for Bruegel seems to have come from book illumination, since few panel paintings with winter scenes preceded his. While such a connection seems highly probable in view of the splendidly progressive quality of miniature winter scenes all the way from the *Très Riches Heures* (1413–16) to the *Grimani Breviary* (c. 1510), research on this point is but in its infancy, and no clear statement can as yet be made. In any case, this bond with book illumination appears to have been somewhat closer *stylistically* for winter than for the other seasons, where the connection is almost exclusively of an iconographic nature.

Little can be said in a general way about the artistic sources of Bruegel's vision of man and his activities as it is embodied in the "multiple" as well as the "single" scenes of this group of works. The little that can be established will be discussed in the notes to each individual plate. As to the multiple scenes, book illumination again emerges as a possible source; children's games, for instance, were represented before in miniatures and prints. But here again, we know very little; and it is indeed doubtful whether intensified research will yield much since Bruegel's interpretations are rather incommensurable in any case. And if this is true of the more popular subjects and scenes, it is even truer of the inexhaustible imagination and compositional greatness with which he endowed his most personal works such as *The Parable of the Blind* (colorplate 36).

Before making an attempt to sketch a picture of both the variety and the consistency of Bruegel's view of the nature of man, I shall, for a moment, concentrate upon one single work that illustrates what one may consider the very core of that view. The small picture of *Christ and the Adulteress* in Count Seilern's collection (fig. 9) is one of the few *grisailles* painted by the artist during his mature period, a painting done entirely in various shades of gray, with some touches of brown, and dated 1565. It was copied in painting frequently, if sometimes irreverently, and the engraving made by

Pierre Perret in 1579 is actually the most reliable reproduction of the painting we had prior to the rediscovery of the original. The history of the work proves that Bruegel kept it for himself until his death, and it contains Bruegel's main moral credo: *humility* and *tolerance*. We are here confronted with one of Christ's greatest and most emphatic, and at the same time most demanding teachings (John 8:7): "He that is without sin among you, let him first cast a stone at her." These are the words which Christ is just beginning to write on the ground in Bruegel's own language (*Die sonder sonde is die . . .*), and which the print quotes in Latin: *Qui sine peccato est vestrum, primus in illam lapidem mittat.* The composition of the picture, undoubtedly influenced by a close study of Raphaelesque principles of structure, is of marvelous simplicity. On the left are those who are already convinced followers of Christ; on the right, those who just a moment earlier were "tempting him, that they might have [something] to accuse him" (John 8:6) and—with the exception of one who remains hostile—are now pondering the answer he has written down for them concerning the adulterous woman; in the center, that woman herself, in a pivotal position, her form likewise inspired by Raphael, is surrounded by some people who have just begun to understand Christ's message and are turning away from the scene of treachery and cheap accusation with feelings of shame and embarrassment. A great content has been given equally great form; obviously this *was* a matter very close to Bruegel's heart, so close that he wanted to be reminded of it continuously.

Mention has already been made of Bruegel's contact with the great humanist and geographer Abraham Ortelius; and both of them were in equally close contact with the moral teachings and independent theological ideas of Dirck Coornhert, theologian, philosopher, writer, humanist, statesman, and printmaker (1522–1590), of which tolerance and humility were the alpha and omega. Coornhert and Ortelius were intimately linked to a group of Catholics who had preserved Erasmus' deep skepticism toward both the Old Church and the Reformers, and who had never abandoned the search for Christian truth and life outside the confines of a church and a clergy which were all too obviously and all too heavily preoccupied with mundane matters. It was Ortelius who once wrote about the "Catholic

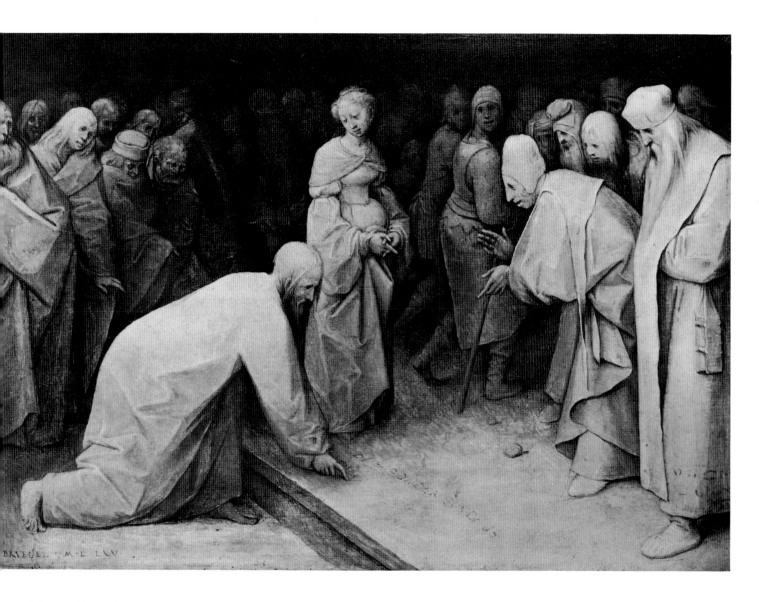

Figure 9. Bruegel. CHRIST AND THE ADULTERESS.
Signed and dated 1565. Panel, $9\frac{1}{2} \times 13\frac{1}{2}''$.
Collection Count Antoine Seilern, London

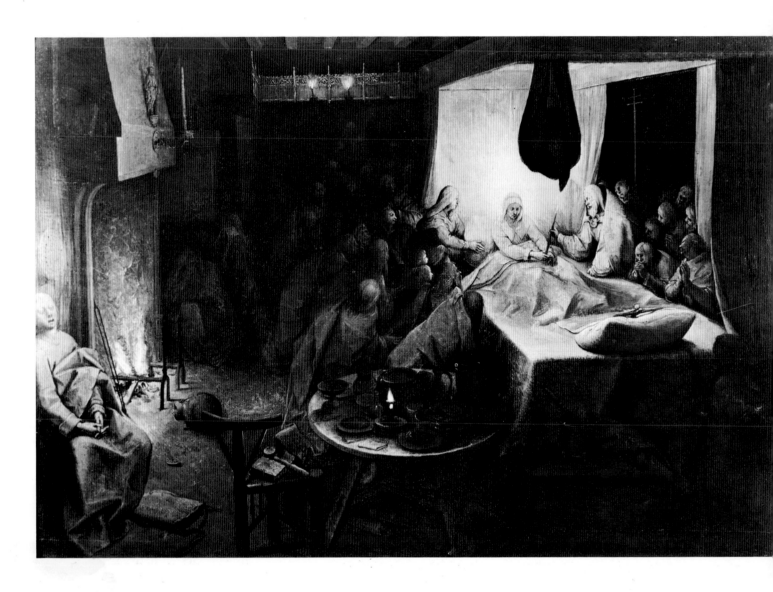

Figure 10. Bruegel. THE DEATH OF THE VIRGIN.
Signed; datable c. 1564. Panel, 14½ × 22″.
Upton House, National Trust, Banbury

20

evil, Protestant fever, and the Huguenot dysentery," and who said of a famous scholar of his time (Justus Lipsius): "It is not clear to me whether he is an adherent of the Pope or a Calvinist; but if he has ears to hear he will be neither; sins are committed within and without [on both sides]."

That by "Catholic evil" Ortelius did not mean the veneration of saints, and in particular, the veneration of the Virgin Mary, is proved by the fact that Bruegel painted for him (c. 1564) the small *grisaille* with *The Death of the Virgin* (fig. 10); the owner had it engraved by Philip Galle with Latin verses which however do not explain (perhaps with good reasons) the very unusual features of this representation of a very popular subject. Following *The Golden Legend* by Jacobus de Voragine, the dying Virgin is here surrounded, not by the Twelve Apostles alone, as was the custom (to which the text adheres), but by a vast number of patriarchs, martyrs, confessors, and holy virgins, who out of the dark are thronging into the simple room. The light surrounding the Virgin is a supernatural one; the burning candle offered her by Saint Peter does not produce it, and this feature may be significant. Nor do the other sparse light sources explain the brightness that illuminates the head of the sleeping figure in the left foreground. This is Saint John the Evangelist who, according to an apocryphal report cited in *The Golden Legend*, recorded Mary's death in this miraculous form, and Bruegel seems to have thought of him as dreaming it. This is the artist's most daring exploit of artificial light effects, used not for the sake of experimenting, but of achieving spiritual aims of great depth, an extraordinary anticipation of Caravaggio and of Rembrandt.

To the sentence about the "Catholic evil, Protestant fever, and the Huguenot dysentery" quoted above, Ortelius added the following words: "All this we have deserved through our sins; for we are motivated by pride and ambition; everyone wishes to be called, but not to be good; everyone wishes to teach others, but not to be humble himself; to know much and to do little, to dominate others, but not to bow under God's hand. May He be merciful to us, and grant us to see our faults." The humility and tolerance expressed in such utterances by Ortelius and in many writings by Coornhert must have been an important, perhaps the most important, element in the thoughts

of Bruegel, and the all-pervasiveness of this creed is another indication that the "Peasant-Bruegel" was a city child reared in an environment where these matters were discussed and put to the test constantly —even though he often visited the countryside for an intensive study of the uninhibited life of the peasantry. He never ceased to appeal to the conscience of his fellow citizens, for whom he depicted sin as a result of lack of knowledge of himself and considerateness of others, and of a tendency to yield to excesses and fanaticism. Again and again he wanted to remind himself and others of the story about the Adulteress (fig. 9) which ends with the words: "And they which heard it, being convicted by their own conscience, went out one by one, beginning at the eldest, even unto the last: and Jesus was left alone, and the woman standing in the midst" (John 8:9). To help people to be "convicted by their own conscience" was one of the overriding aims of Bruegel's art—and he did not hesitate to use strong means to achieve it.

It is true that Bruegel reached the heights of lucidity in content and form which distinguish *Christ and the Adulteress* only during the later phase of his short career. At first sight, his early works do not even seem to be related to this aspect of his art; yet, closer inspection allows for a different view of them.

Bruegel's first comments on man, so far as they are known to us, were made in drawings destined for publication through prints made by professional engravers, under the guidance of his friend, the publisher Hieronymus Cock. They precede comparable paintings by about three years. *The Ass in the School* (fig. 11) and *The Big Fish Eating the Little Fish* are dated 1556; in 1557–58 Bruegel designed the great series of the "Vices" (prior to that of the "Virtues," 1559–60). The allegory of *The Big Fish* (fig. 12) is an important witness to the fact that even at this early time, Bruegel occasionally aimed at that economy of compositional means which became the hallmark of his later paintings; its structure is dominated by the huge curve of the back of the big fish, to which the curve of the boat in front and of the smaller fish in the left foreground correspond with power and a certain gracefulness at the same time. Already Bruegel, inspired by a composition by Hieronymus Bosch, uses a popular saw to convey the results of man's moral frailty, his tendency to succumb to greed, to

be corrupted by power and wealth, to ignore the plight of the small fry. Pieter van der Heyden's engraving of 1557 after this drawing is reproduced here (fig. 13) as an example of how Bruegel's drawings were presented to the audience of his time; the didactic element was here emphasized by adding *Ecce* (Behold [how man behaves]) to the father's gesture.

But on the whole, early designs—in drawings and corresponding prints—follow a pattern of great compositional crowding such as Bruegel found employed in popular prints after Bosch, which he occasionally emulated in drawings (figs. 2, 3), and in some more recent artists such as Frans Hogenberg (figs. 44, 48), and Pieter van der Borcht. The multiplicity of Bruegel's designs for the "Vices" is rooted in this tradition, but already here he outshines his forerunners by virtue of his incomparable ability to convey mental attitudes and moods through bodily poses and actions of the greatest precision and pregnancy.

Confronted with the task—or rather, setting himself the task—of characterizing human vices (figs. 14, 22) in order to hold up a mirror imparting self-knowledge, Bruegel felt he needed the same emphasis through variety that had reigned over the most successful previous literary and pictorial compendia of human folly, Sebastian Brant's *Ship of Fools*, Erasmus' *Praise of Folly*, and Bosch's unforgettable comments on human folly under all conditions, outside and inside the vehicles of sin and punishment. With this, he also conformed to a universal tendency of his generation, which had seen at least as much folly and disaster in human affairs as other periods, and which had in any case learned to be more pessimistic about human nature than preceding generations had been. Irony is one of the strongest weapons in the battle for truth, and it was the truth of the human condition in its uninformed state that Bruegel wanted to reveal. In his tableau of *Desidia* (*Sloth*), the catalogue of pregnant versions of indolence is seemingly inexhaustible (the drawing, fig. 14, is of 1557, the engraving, fig. 15, of 1558). Desidia herself, with the melancholy gesture appropriate to non-action, lies across a lazy donkey; a pillow is provided by a demon, because "laziness is the Devil's ear-pillow"; the creepy figure in the right foreground carries a knife in his cap since indolence leads to both choleric viciousness and gluttony. A lazy pig, half hidden by a bare and hollow (no-good) tree, chews on a melancholy thistle. On the other side, a slothful glutton has breakfast in bed, attended by a rat (sleeping mouse or *slaapmuis* in Netherlandish). The hut is dilapidated; an ax is unused and unusable ("when I rest I rust"); a couple in bed illustrates the connection between sloth and lasciviousness, aided by wine and dice. A huge figure in the center of the background is too lazy to relieve himself and must be prodded along; the water near the mill is too still to be useful; the eleven on the clock is the fool's number. It may be that the bell, which a man on the tree that penetrates the roof of the hut is ringing, is a call to repentence; but it certainly is a pun on the Netherlandish word *lui*, which can mean both a bell sound and lazy—and the people to boot. Puns and proverbs are already potent weapons of Bruegel's art.

It is this compendium-like, cataloguing imagery, this crowding of innumerable details into one composition which characterizes Bruegel's earliest paintings (outside of landscapes), those dated 1559 and 1560 (colorplates 3–7). They share with the prints of the "Vices" the magnificent clarity in rendering human forms in such a way as to reveal the exact movements of their bodies and the motives of their actions. But in addition, they translate the black and white of drawing and print into magnificent colors, the careful choice of which contributes greatly to their overall compositional unity. As in the vast majority of cases, we have no information whatever about the conditions under which Bruegel painted these large panels, whether they were commissioned to him or whether he, the successful designer of professionally reproduced drawings, considered the output of large paintings a more or less private enterprise in which only trusted friends took interest; while the former is the more probable assumption, we have nothing to substantiate it (outside of the series of "Months" of 1565). The problems posed by Bruegel's choice of colors have hardly ever received close attention; it is an area of tremendous variety and complexity, partly caused by technical differences in the selection and use of pigments in painting on canvas and on panel, even apart from the question of preservation which varies widely between the two groups. The text to our plates will call attention to some particularly noteworthy examples.

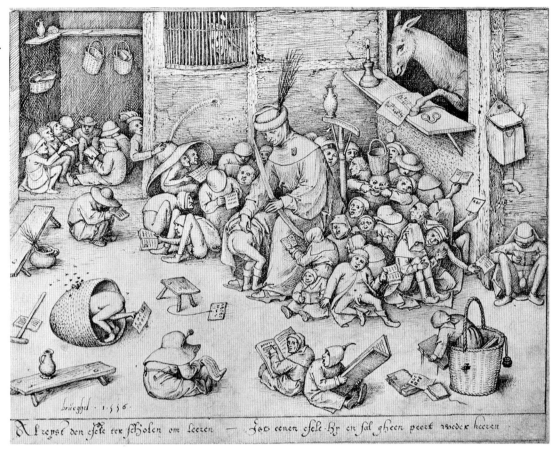

Figure 11. Bruegel.
THE ASS IN THE SCHOOL.
1556. Drawing, 9 ⅛ × 12 ⅛″.
Kupferstichkabinett,
Staatliche Museen, Berlin

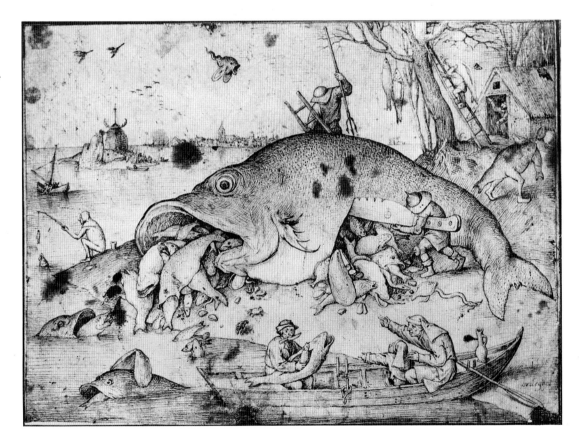

Figure 12. Bruegel.
THE BIG FISH EATING
THE LITTLE FISH.
1556. Drawing, 8 ½ × 12″.
Albertina, Vienna

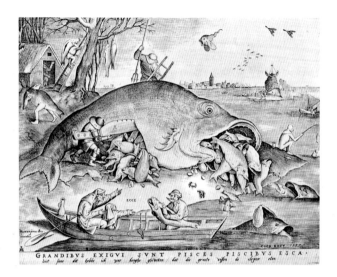

Figure 13. Pieter van der Heyden after Bruegel.
THE BIG FISH EATING THE LITTLE FISH.
1557. Engraving, 9⅛ × 11¾".

It is perhaps less self-explanatory than in the case of the "Vices" that Bruegel's series of the "Virtues" (figs. 16, 17) contains so many comments on human weakness. But Bruegel was not the man to incorporate none but positive qualities in such a series; this would have produced little more than a rehash of what must then have looked like medieval truisms. The time when Hope could be represented in the form of a beautiful female figure reaching for the crown of Heaven, such as she appears in Giotto's fresco in the Arena Chapel in Padua, was past. Hope was now seen in terms of mundane aspirations and even outright misdirection. Bruegel's "Virtues" are no idealized theological concepts, but allegories based on human activity *which can go in either direction*. This is a concept which occurs over and over again in Coornhert's writings. Such action is, of course, dependent upon insight into the essence of virtue if it is to develop in the right direction. *Theoria* means insight; man must have a clear idea about what constitutes virtue. And this can be acquired only through an active and close relationship to the teachings of Christ, a real *Imitatio Christi*, rather than a mere acceptance of the teachings of the Church. Again and again, even the "Virtue" series makes this point: we must choose, and we must choose in the light of what Christ's life teaches us. While Coornhert and Bruegel did not rebel openly against the Church, they did deny that its role as

a mediator is more important than man's direct relationship to God. If this were not so, the warning, the negative, the threatening elements in Bruegel's allegory of *Spes* (*Hope*; fig. 17) would be unintelligible; and he would have continued in the tradition which said that if you trust the mediating authorities, nothing could go wrong. Plenty can go wrong in what *this* Hope reveals to us. The inscription, added by a later hand on the drawing but also appearing on the print, speaks of the "necessity" of hope since human life is burdened with "almost intolerable troubles"; and these are depicted as perishing ships, harassed survivors, languishing prisoners, a house going up in flames. Only in the far distance there reigns peace: a farmer, a man setting a fish trap(?), and a few boats go about their business untroubled. But even the figure of Hope herself is not exempted from threats and uncertainties. She stands on an anchor—an old attribute of hope—but the anchor is *swimming* on the turbulent waters, and a big fish is trying to pull it away. A number of features of this design are derived from a woodcut made in 1545 by Heinrich Vogtherr; but Bruegel's very own idea in this composition is the much greater emphasis on pessimism, on the precarious and ambivalent nature of Hope, and it is even possible that the beehive on her head is an allusion to the "Bee Hive of the Romish Church," against which Philip van Marnix was to write a scathing pamphlet in 1569, the year of Bruegel's death.

Returning from here once more to the series of the "Vices," one sees perhaps more clearly now that they all contain one unifying element. Ignorance is "the only sin" or at any rate the "root of all other sins" according to Coornhert. "It is puffed-up ignorance alone that causes people to commit sins." The king, before whom Calumny and her vicious cohorts slander Truth (*Veritas*) in Bruegel's extraordinary adaptation of Botticelli's *Calumny of Apelles* (fig. 18), is advised, conforming to Lucian's text, by *Suspicio* and *Ignorancia*; they are certainly "puffed-up." It is clear that the "Peasant-Bruegel" has here consulted his humanist friends in his earnest attempt to prove, from classical sources as well, the fatal role of ignorance in man's wrong decisions and sinful acts. This is indeed not Biblical territory, in which sin springs from knowledge rather than from ignorance. In contrast to the orthodox view and also to the great re-

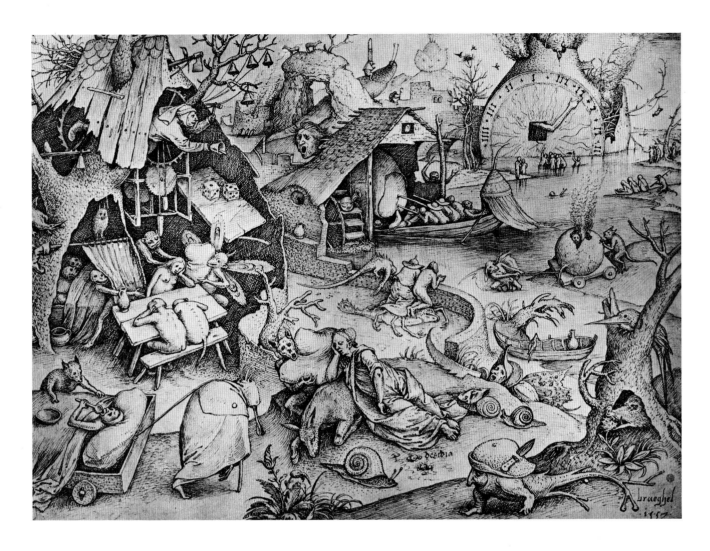

Figure 14. Bruegel. DESIDIA. 1557.
Drawing, 8½ × 11¾".
Albertina, Vienna

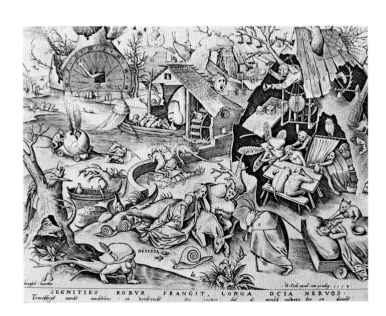

Figure 15. Pieter van der Heyden after Bruegel.
DESIDIA. 1558. Engraving, 9¼ × 11¾"

25

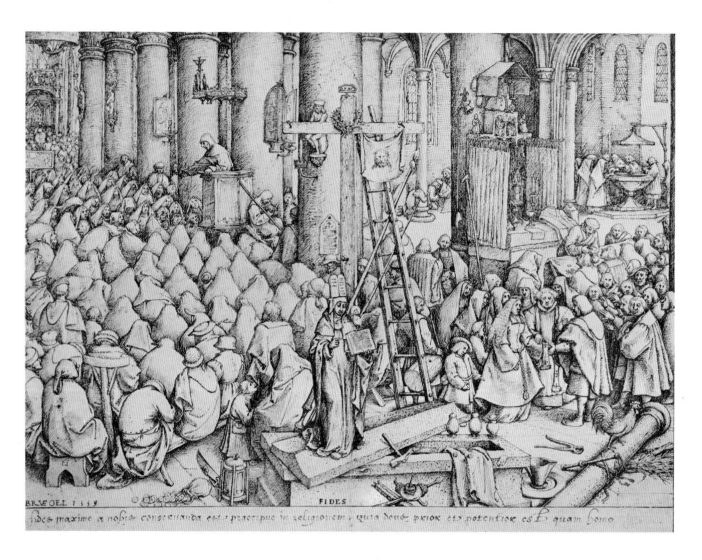

Figure 16. Bruegel. FIDES. 1559.
Drawing, 8¾ × 11¾".
Rijksmuseum, Amsterdam

formers, Erasmus, Coornhert, and with them, Bruegel, see sin not as something necessarily inherent in man even after the Fall; on the contrary, when man sins, he acts *against nature*. In the famous design of *"Elck"* (*Jedermann, Everyman,* fig. 19), Bruegel stresses his belief that although man can make the decision to conform with the best in his nature, he usually does not do so because he refuses to know himself, to know his better nature, and represses it out of stupidity and greed. The picture on the wall is inscribed: "Nobody knows himself." It is true that this picture has its ambiguity; perhaps it can be interpreted not only as the personification of that elusive person called "Nobody" who knows himself (in the mirror reflection), but also, at the same time, as the wise fool, who *plays* the fool by denouncing the ways of "Everyone." Equally ambiguous is the figure of Elck going to church (in the background) in deep solitude: is there still hope or is it too late? Is going to church just an empty gesture of the sinner? Did Bruegel mean to say that the church is falling down on its job (as he might have suggested in *The Parable of the Blind,* colorplate 36, as well)? Here the spectator must choose for himself—both the meaning and the way.

Human stupidity and folly are pointed up over and

26

over again as the worst companions of the ignorance that begets sin; the stupid and the foolish are either too lazy or too lighthearted to take the matter of knowing themselves seriously. *The Alchemist* (fig. 20) becomes the epitome of such folly coupled with stubbornness and neglect of his family, that is fanaticism and self-seeking; as he squanders his last pennies in his vain attempt to evade all sensible rules of nature and society and to make a "fast buck" by clinging to his obsession, his family goes hungry. The design of this sheet is similar in type to that of the Elck allegory (fig. 19) and also of that satire on the folly of witch-

craft, *The Witch of Malleghem* (fig. 21). But as the years advanced, Bruegel more and more often followed the trend which he had already initiated in *The Big Fish* (figs. 12, 13), the increasing clarification and monumentality of composition through eliminating the wealth of details, and through concentrating upon a single or a few motifs. Proverbs and legendary concepts now become the main carriers of the message— but in terms of one item rather than the many that Bruegel had accumulated in the Berlin *Proverbs* of 1559 (colorplate 5). This development was to reach a first climax in *The Land of Cockaigne* of 1567 (color-

Figure 17. Bruegel, SPES. 1559.
Drawing, 8¾ × 11¾".
Kupferstichkabinett, Staatliche Museen, Berlin

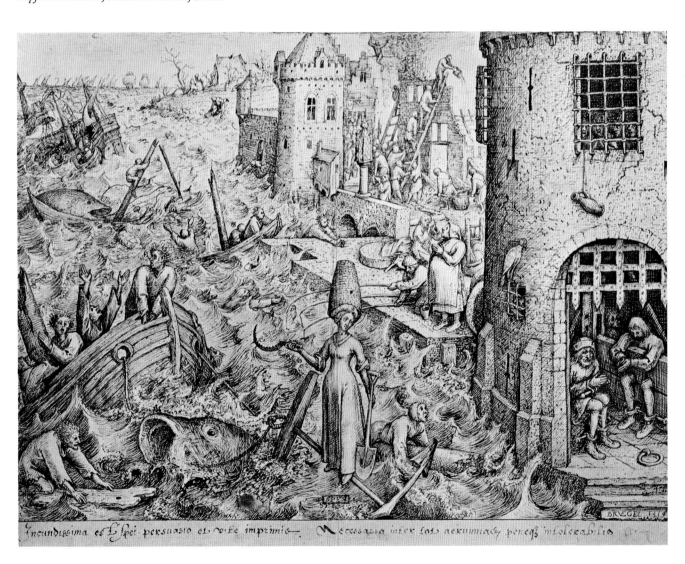

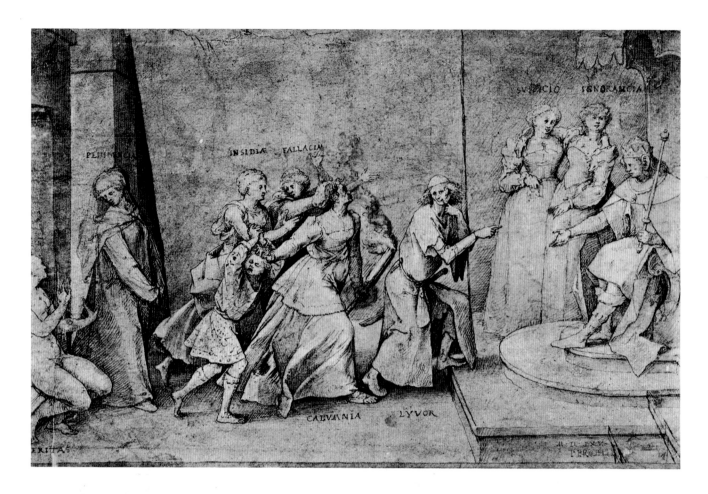

Figure 18. Bruegel. THE CALUMNY OF APELLES. 1565.
Drawing, 8×12″. *British Museum, London*

plate 30), in which the concept of gluttony, instead of being illustrated piecemeal in a host of details (as it had been in the *Gula* of 1557 in the series of the "Vices," fig. 22), has been conveyed with overwhelming power through a group of only three representatives of humankind who are defined by the roundness and bulk of their bellies as relentlessly as the scenery is by the corresponding roundness and bulk of tree, table, and riceberg. It is this saturation of the entire composition with significant visual symbols of the core of the content—symbols derived from reality and observation, not from tradition and borrowing—that distinguishes all of Bruegel's late works in which he presents his view of the nature of man: sometimes more fiercely, sometimes more leniently, but always critically with the aim of persuasion, of helping the spectator to be "convicted by his own conscience." This is great art, and as such

it is a source of deep satisfaction; but surely there is no room here for a *purely* aesthetic response. The rule applies equally to messages conveyed through a proverb, a newly devised concept, peasant festivals, and even some Biblical stories which involve sin, with or without obvious punishment. And in all this, Bruegel speaks because he knows; inside and from insight, not from without.

Outside the coveted but unconquered land of humility and tolerance, there was only one realm in which Bruegel sought and expressed relief from human folly, selfishness, and hypocrisy. This was the realm of nature; nature as seen by one of the greatest pacemakers in the history of landscape art.

28

In some of the allegories of "Vices," "Virtues," and others, landscape is occasionally involved in the doings of man and used to point up a special moral which is the main burden of such a composition. In the allegory of *Spes* (fig. 17), nature is seen in terms of man's stormy experience, a threatening and hostile power. But even there, a real ray of hope is embodied in a bit of peaceful background landscape in which people go about their business blessed with the abatement of destructive forces; and something comparable happens in the backgrounds of the *Proverbs* (colorplate 5) and the *Children's Games* (colorplate 7). But it will be remembered that Bruegel actually began his artistic career, as far as we can trace it,

with landscape drawings and an occasional landscape painting. To him, the South meant landscape. He drew actual sites in Rome, Naples, Reggio di Calabria, Messina, and in several Italian valleys and mountains (fig. 6); during his return he was overwhelmed by the power and beauty of Alpine summits and gorges (fig. 23), so much so that even at the time of Van Mander, people used to say that he had swallowed the Alps as he crossed them, and then spat them forth on canvases and panels after his return home. He made many drawings of those sites as he passed through them, and we can follow him from the year 1552 on all the way, not only until his return to the Netherlands, but for several years after.

Figure 19. Bruegel. "ELCK." 1558.
Drawing, 8¼ × 11¾".
British Museum, London

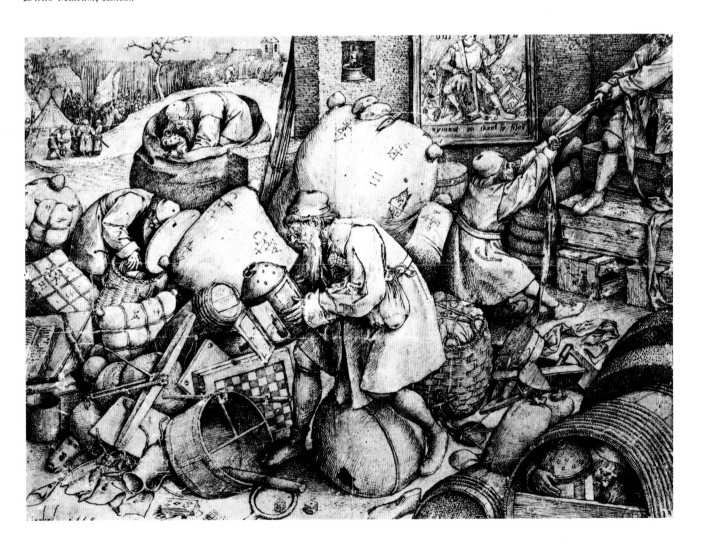

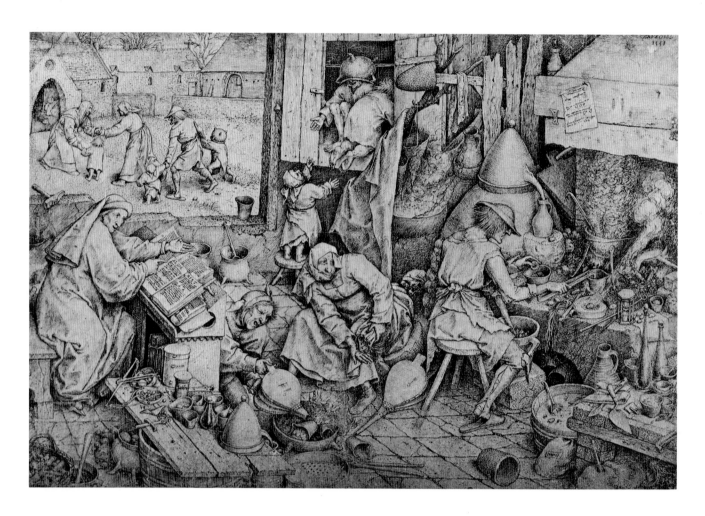

Figure 20. Bruegel. THE ALCHEMIST. 1558.
Drawing, 12 × 17¾".
Kupferstichkabinett, Staatliche Museen, Berlin

Among the landscape drawings which he made from the time of his return from Italy to the year 1562, when they suddenly stopped for good, there are some truly epoch-making ones that are based on the most intimate study of his native surroundings. It suffices to point to the wonderful intimacy of the *Landscape with Church* of 1560 in Berlin (fig. 24), which opens the way not only to the background of *The Harvesters* of 1565 (colorplate 24), but also to the landscape art of Rubens; to the equally tender and subtle *River Landscape* of the same year, 1560 (fig. 25); to the three drawings of 1562 with motifs from the city gates of Amsterdam (fig. 69); and to the extraordinarily precocious *Forest Landscape with Bears* of 1554 (fig. 26), which was etched by Hieronymus

Cock (fig. 27) in what has always been considered one of the pacesetters of landscape art of the sixteenth century even before its connection with Bruegel was realized, and which indeed anticipates Gillis van Coninxloo, Roelandt Savery, and—last but not least—Jan Brueghel the Elder. But in Bruegel's art in general, the synthesis of such native surroundings with the Italianate mountain views plays a much greater role.

In the mid and late 1550s, several years after his return North, Bruegel made many of his greatest drawings with mountain scenes (fig. 28), and had a series of them reproduced in prints (although only two direct preliminary drawings for the series have survived, we have many related ones); and in these

prints (figs. 29, 41) he conveyed to "the people" a comprehensive impression of what nature in its most sublime manifestations had meant to him when he dedicated himself entirely to it during his late Italian years and months. The achievements of his Netherlandish forerunners in this field now seem to lie far behind us; they look like precious *objets d'art* in comparison, with little of the extraordinary presence of Bruegel's images. And this is true although these images are far from being "realistic" in the generally accepted sense of the word. They are syntheses of southern and Netherlandish vistas, composites rather than plausible views; although partly based on more realistic drawings from the South and from the artist's native surroundings, they have forsaken the bond to one individual spot and do not recognize any fixed standpoint or laws of perspective. They are *world panoramas*, entirely in a class by themselves, with their own relationships of foregrounds, middle grounds, and backgrounds, of spaces of valleys, mountains, water, fields, and villages; and in Bruegel's great landscape paintings of his mature period, we find him clinging to the same system or lack of system, as we also do in the only original etching (probably of 1560 rather than 1566) that can be attributed to him with complete certainty (fig. 30). Man's presence in these vast realms, whether in Biblical guise or everyday work, counts little. In a sense one could call these composite landscapes *maps* of what nature here or abroad, the world over, offers to the eyes of man, and this reminds one once more of Bruegel's friendship with the great cartographer and geographer Abraham Ortelius. Maps and panoramas are indeed world views in a double sense when handled by people of that stature. Both Ortelius and Bruegel were discoverers of new worlds, and it is tempting to think of them as a team. Unfortunately even connoisseurs of this branch of knowledge have not been able so far (much remains to be done) to suggest specific similarities, and, equally unfortunately, no proof of actual collaboration between the two men has yet been discovered. However, we do know that, probably in the very year of Bruegel's death, another outstanding Flemish painter, Maerten de Vos (who had been traveling in Italy at the same time as Bruegel) was consulted regarding certain artistic elements of Ortelius' maps and, against Ortelius' advice, recommended coloring them. It is not difficult to imagine that Bruegel, in contrast to De Vos, would have seen eye to eye with Ortelius in this—as presumably in many other matters.

If the composite landscape is a world panorama, it is tempting to see in it a significant parallel to the panorama of human activities in this world which Bruegel has placed before us. The crowded early paintings and drawings present a veritable map and panorama of human folly, and nature is crowded out by them with the exception of a few redeeming glimpses. In the late paintings and drawings, the concept of the map and panorama was abandoned for the sake of a few persons enveloped in more realistic landscapes of the greatest beauty which, in a measure derived from Bosch and destined to culminate in the great landscapes of the seventeenth century, serve as foils and contrasts to human folly and disaster. But in the "Months" and a few other paintings, there is *harmony* between man and nature, at least to a large degree. Some human actions depicted in them are still being characterized as more or less foolish, such as the carnival and inn scenes in *The*

Figure 21. Pieter van der Heyden after Bruegel.
THE WITCH OF MALLEGHEM. 1559.
Engraving, 14 × 18¾"

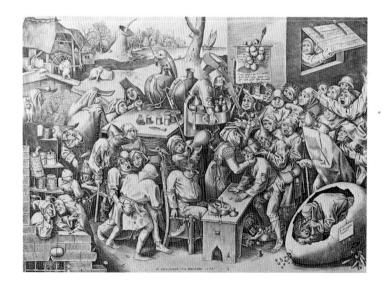

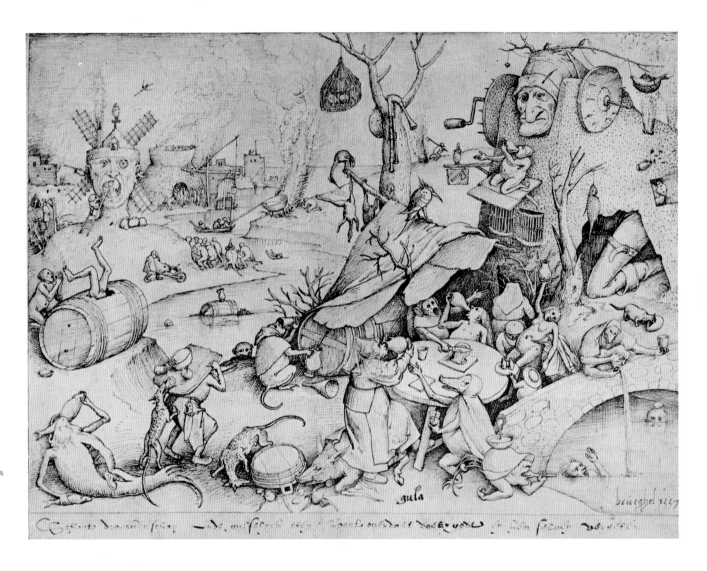

Figure 22. Bruegel. GULA. 1557.
Drawing, 9 × 12″. *Collection F. Lugt, Institut Néerlandais, Paris*

Gloomy Day (colorplate 22); and the uncouthness of
eating, drinking, and sleeping in *The Harvesters*
(colorplate 24) is still faintly reminiscent of the con-
cept of labor as the wages of sin. But on the whole,
man, acting in concord with the seasons and the
occupations of the months, is in a blissful state, and
his labor is the very opposite of the foolish way in
which he sins against God, and man in the image of
God, in the paintings which depict his activity on
wedding days and saints' days. The highest degree
of uncontaminated bliss occurs in *Haymaking* (color-
plate 23), which contains that wonderful trio of
joyful women who have just finished their day's work
—and who characteristically are also more handsome
than any other figures ever painted by Bruegel; the

harmony of their walk reflects the perfect harmony
which here for once has been achieved between nature
and man. No wonder that Rubens (fig. 66) was deeply
stirred by this picture as he also seems to have been
by the matchless serenity of the *Landscape with the
Flight into Egypt* of 1563 (fig. 8). One glance at the
hopeless chasm that opens up between man's folly
and nature's unsullied purity in *The Misanthrope*
(colorplate 35) allows us to gauge the immense con-
trast between Bruegel's two main views of the relation-
ship between nature and man—and the immense range
of his visual imagination.

There exist some drawings and prints in which
Bruegel combined landscape with somewhat larger,
more significant figures or figure groups than he used

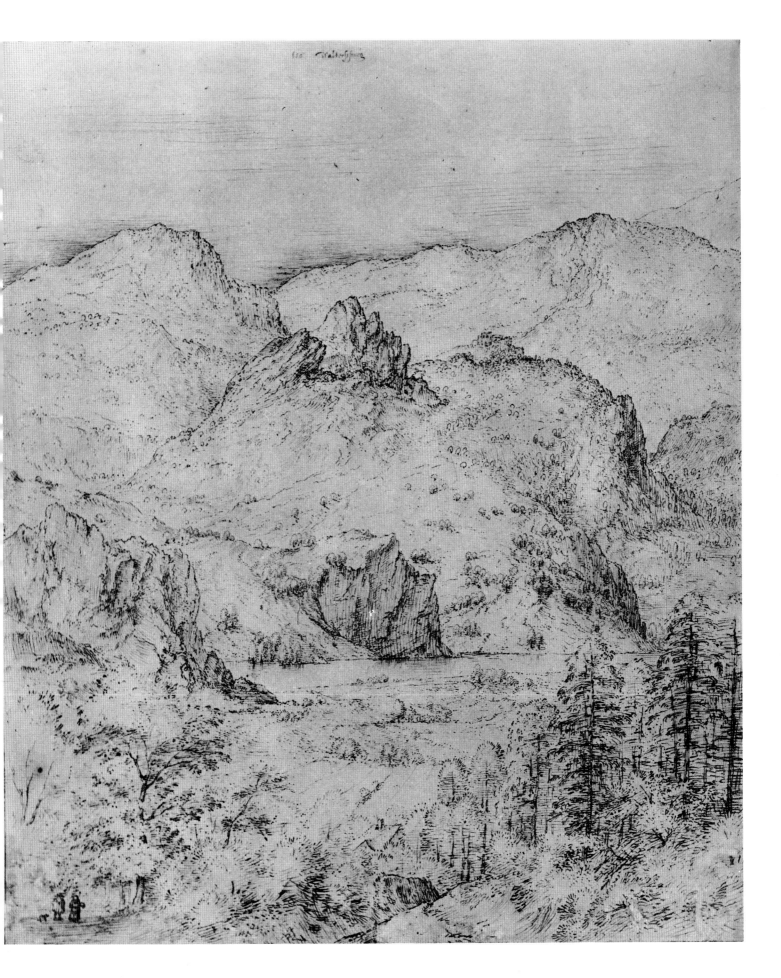

Figure 23. Bruegel. VIEW OF WALTENSBURG. c. 1553–54.
Drawing, 12½ × 10¼″.
Bowdoin College Museum of Art, Brunswick, Maine

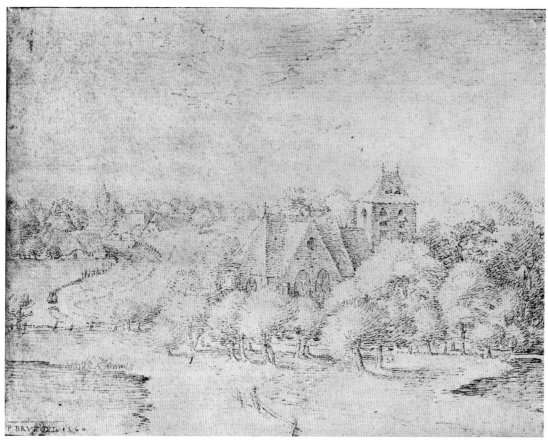

Figure 24. Bruegel.
LANDSCAPE
WITH CHURCH. 1560.
Drawing, 5¾ × 7½".
Kupferstichkabinett,
Staatliche Museen, Berli

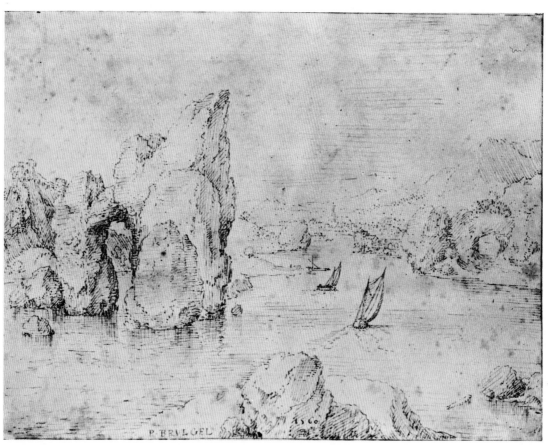

Figure 25. Bruegel.
RIVER LANDSCAPE. I
Drawing, 5¾ × 7½".
Kupferstichkabinett,
Staatliche Museen, Berli

in other designs of this kind, and in which he did not aim at the contrast between man and nature emphasized in the paintings we have already discussed. This is particularly true of a pair of drawings and prints representing *Spring* and *Summer*, later supplemented by an *Autumn* and a *Winter* designed by a different hand. Bruegel's original drawings for the *Spring* and the *Summer* have survived but the former is dated 1565, and the latter, 1568; it seems almost certain that they were not intended as companion pieces by Bruegel himself, who inscribed the *Spring* (fig. 31) with the names of the months March, April, and May, but did not treat the *Summer* (fig. 32) accordingly. The drawing of 1565 corresponds closely in spirit to the series of paintings with the "Months" of the same year; man's work in nature, with nature, conveys upon him a dignity of a simple, uncomplicated kind, the whole atmosphere is relaxed, the distribution of the groups blends smoothly with the serene landscape. In the *Summer* of 1568, an entirely different spirit is at work; in a much generalized way, one might say that the *Summer* is as typically Mannerist as the *Spring* is the progeny of late medieval book illumination, and at the same time an ancestor of the Baroque. The *Summer* is dominated by two seemingly abstruse, nearly faceless figures, one epitomizing labor, the other, rest; the drinker is a paraphrase of both the *Laocoön* and of a Michelangelesque motif, a prime example of the Mannerist tendencies which appear in Bruegel's output at odd intervals, and which in the highly personal interpretation of the *Resurrection of Christ*, an undated *grisaille* painted on paper (Museum Boymans-van Beuningen, Rotterdam) and known also through a splendid engraving (fig. 33), had already led to an extraordinary anticipation of works by El Greco. In the *Summer*, nature is not allowed to flow unimpeded around the figures as it does in the *Spring*, although it is not really oppressed by them; there is a new tension here but it is of a very delicate kind, and in the *Landscape with the Magpie on the Gallows* (colorplate 38), also of 1568, that tension is, as it were, shown in reverse: between small figures and a large landscape. We can always only guess at what might have been in store for great artists who die in the prime of their lives.

It will have been noticed that one somewhat isolated but very large and very popular group of drawings by Bruegel has so far not been mentioned, and will never be mentioned in the text to the plates, namely the "naer het leven" group. The reason for this is its strange unrelatedness to Bruegel's paintings, and the host of uncertainties surrounding its meaning. It consists of no less than about seventy drawings representing one or more peasant figures (figs. 34, 35), a few beggars (fig. 36), soldiers, traders (fig. 37), etc., all seated, standing, or (rarely) walking, but never shown in real action, and a few animals (figs. 38, 39). In contrast to the few quick preliminary sketches for corresponding figures in paintings (figs. 58, 63), they are more elaborately finished with the pen and brown ink over the light black or red chalk outlines, and many of them are inscribed, either with color notes pertaining to their costumes, or with the caption *nart* (or *naert—naer het*) *leven*, or similar spellings, meaning from life, or with both color notes and inscriptions, always in the ink with which the design itself was finished. In spite of the color notes, not one of these was used in a painting; not one of them is signed by Bruegel himself; not one of them is dated. Their figures share the impersonality with many that do occur in Bruegel's paintings; many are seen from the back. They are tightly wrapped up in their clothes and often look uncouth; the horses (fig. 38) and the mule (fig. 39) are overworked creatures. The term "from life" (*naer het leven*) for studies from reality, was used by some other artists shortly before and contemporaneously with Bruegel; the opposite term is "from the mind" (*uyt den gheest*), as Van Mander calls it; but the completion of each of these drawings is undoubtedly a matter of work in the studio, perhaps quite removed from the original site. Some of these drawings are masterpieces of characterization of a pose of relaxation, of a sour mood, of stolid waiting, rarely of an expectation or a conversation. But the pen work is often somewhat crude and seems to hide a finer underlying sketch such as has remained visible in the preliminary drawings (figs. 58, 63). Much remains to be done in further investigating the real meaning and origin of these works, and perhaps also in viewing them more critically in their present form.

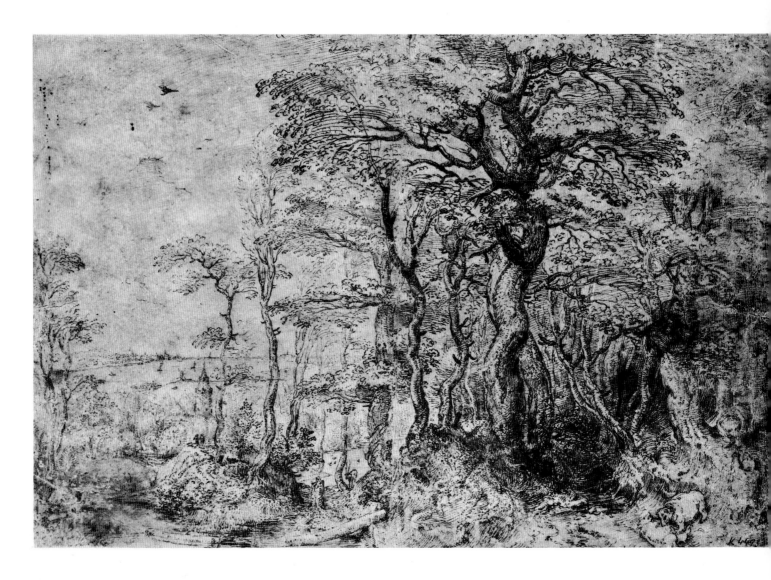

Figure 26. Bruegel.
FOREST LANDSCAPE WITH BEARS. 1554.
Drawing, 10¾×16¼″.
National Gallery, Prague

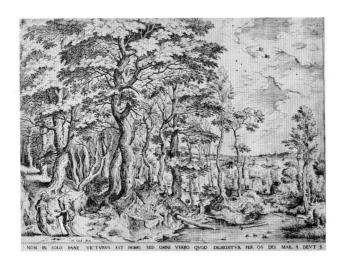

Figure 27. Hieronymus Cock after Bruegel.
LANDSCAPE WITH THE TEMPTATION OF CHRIST. C. 1555.
Etching, 12½×17″

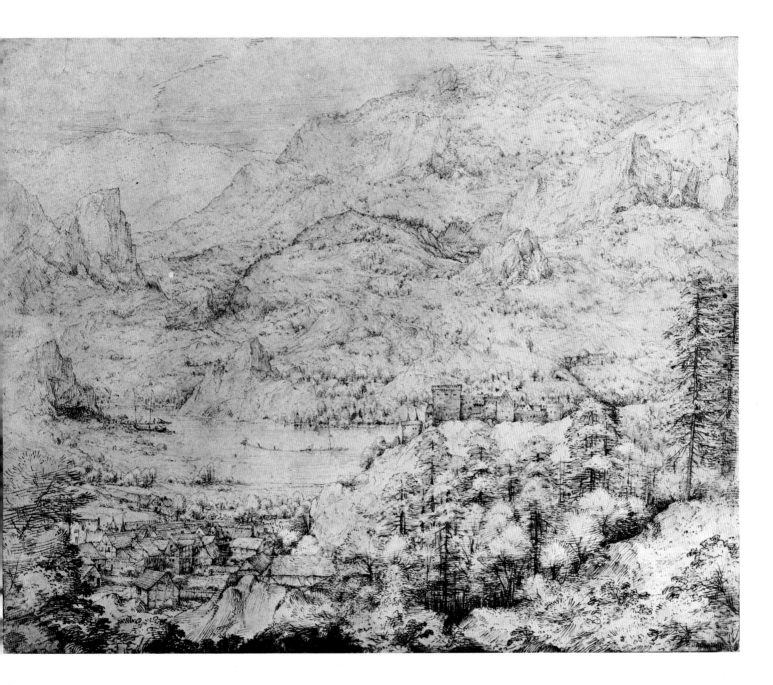

Figure 28. Bruegel. MOUNTAIN LANDSCAPE. c. 1554–55.
Drawing, 13¾ × 17¼″.
The Pierpont Morgan Library, New York

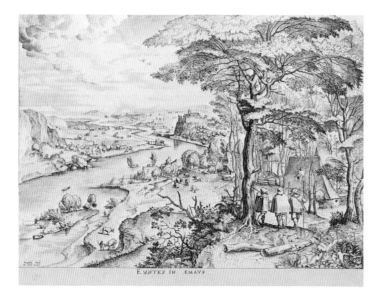

Figure 29.
Jan and/or Lucas a Duetecum after Bruegel.
LANDSCAPE WITH THE JOURNEY TO EMMAUS.
c. 1555–60.
Etching and engraving, $12\frac{3}{4} \times 16\frac{7}{8}''$

Figure 30. Bruegel.
LANDSCAPE WITH A RABBIT HUNTER.
1560 or 1566.
Etching, $8\frac{1}{2} \times 11\frac{1}{4}''$

Figure 31. Bruegel. SPRING. 1565.
Drawing, 8¾ × 11½″. *Albertina, Vienna*

Many years after Bruegel's death, Carel van Mander characterized him as both *bootigh* and *gheestig*, that is, funny and spirited. By stating that one cannot look at works by Bruegel without chuckling or smiling, Van Mander referred to a reaction to his art which we can witness in many observers of today as well. Bruegel would have forgiven them; for the people of his time were not priggish about this kind of thing, and it is quite possible that Bruegel meant to be *bootigh* to a degree. But when Van Mander called him *gheestig* (spirited, inventive, brilliant, refined—all these are included in the term *gheestig*), he referred not only to an artistic superiority, but also to a mental and even moral superiority. Theoreticians of painting in the second half of the sixteenth century speak of

two main aims of painting: pleasure and moral profit (*plaisir* and *utilité*); it was a characterization that Poussin, in the following century, was to express in a single word which has often been misunderstood, but which really includes both pleasure and profit: the word *délectation*. But most of the artists who followed such precepts sought to embody the matter of moral profit in subjects directly pointing up moral deeds as such, either in terms of religious stories, or of moral tales from antiquity, or of elaborately designed (and often thoroughly chilling) allegories. Bruegel was a moralist; but in order to engage the observer fully, in order to speak to him in such a way that he cannot but listen, the artist, instead of using the indirect route of tales and allegories, preferred to

39

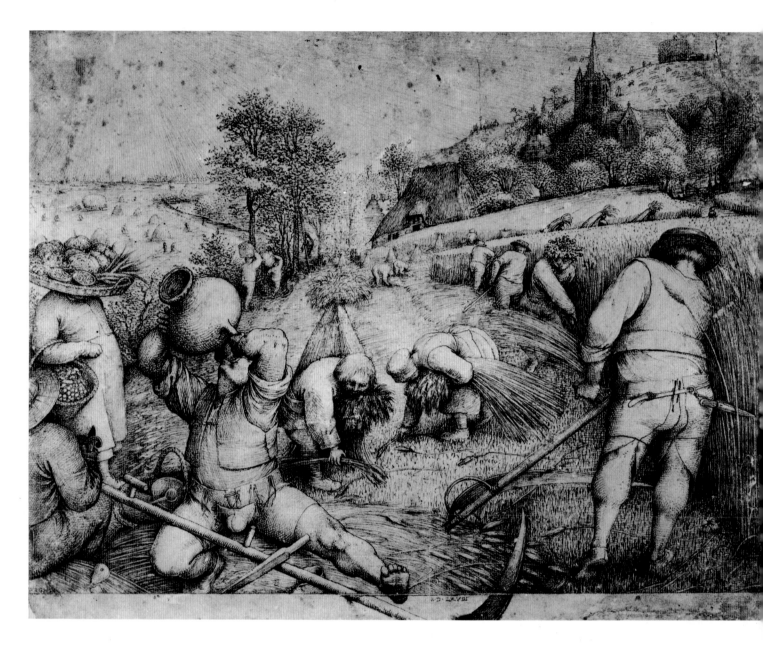

Figure 32. Bruegel. SUMMER. 1568.
Drawing, 8⅝ × 11¼". *Kunsthalle, Hamburg*

go *medias in res*, or—if the expression is allowed—*medium in hominem*. He used a language which, though full of picturesque allusions, was at the same time of great directness; above all, he never failed to transform whatever he wanted to say into full-blooded and, as Abraham Ortelius wisely remarked in his epitaph on Bruegel, unprettified visual reality. Aided by an incorruptible eye and an incomparable skill in giving each content exactly the formal garb for which it craved, he was able to convey to the people of his time—and of our time—the full impact of his message of hope despite everything, and beyond that, his message about the necessity of man's constant alertness and responsibility in the crucial matter of the survival of human dignity, expressed again and again in images of its violation. It is, as has been emphasized before, highly significant that he spoke about these matters in his popular prints as urgently as he did

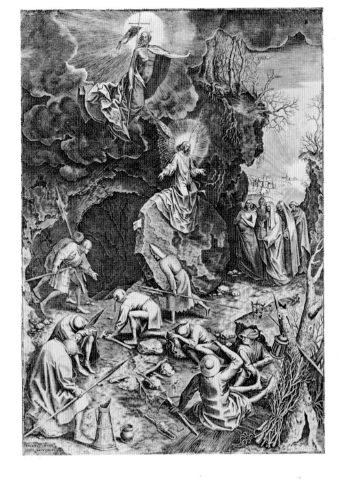

Figure 33. Philip Galle after Bruegel.
RESURRECTION OF CHRIST. C. 1565.
Engraving, 17⅝ × 12½″

Figure 34. Bruegel.
TWO PEASANTS. C. 1560–65.
Drawing, 5⅞ × 7⅜″.
Cleveland Museum of Art.
J. H. Wade Fund

41

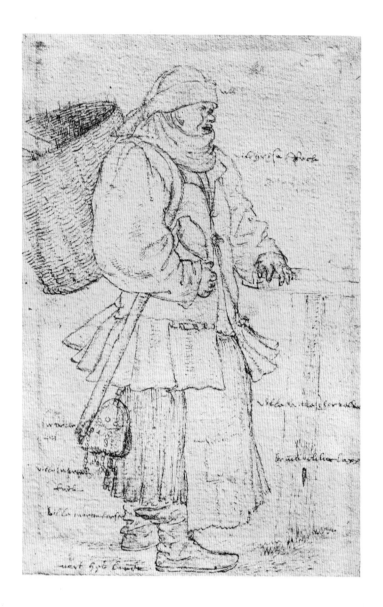

in his great paintings. The parallel with Albrecht Dürer again suggests itself—if translated, as it must be, into the language of the middle of the sixteenth century, of the time of the *Götterdämmerung* of the reform movements, the concomitant deep pessimism, the Mannerist surfeit with, and reaction against, High Renaissance ideals and forms. But this was also the time of Coornhert and Ortelius, of a courageous watch on the ramparts, of an urge to gather a group, however small, of spiritual leaders who spoke their minds, even if it had to be done in ambiguous language, and who spoke thus not to the few but to all, exhorting, pleading, even censoring and threatening.

We know that Bruegel died young. The old painter of the famous drawing in Vienna (fig. 40) can hardly be considered a self-portrait properly speaking. Yet, Bruegel must have spoken here about himself, and although the content of this wonderful drawing has been interpreted in various ways, I do not doubt that it is basically a spiritual self-portrait, somewhat in the same sense in which Dürer's *Melencolia I* is a spiritual self-portrait. The "connoisseur" at his right, who looks at what the painter is about to put on the invisible panel or canvas, is hardly an outright caricature. He is Elck. He does not know what he sees—this is quite clear from the vacuous expression on his face; he does not know whether what he sees is worth anything—this is clear from the undecided

Figure 35. Bruegel. PEASANT WOMAN. c. 1560–65.
Drawing, 6¼×4″. *National Museum, Stockholm*

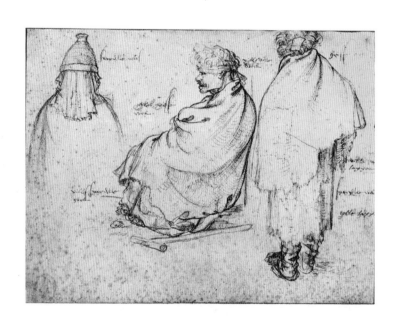

Figure 36. Bruegel. THREE STUDIES. c. 1560–65.
Drawing, 6⅛×8⅛″.
Museum Boymans-van Beuningen, Rotterdam

way he fumbles around with his purse; he is uninformed, uncertain of himself, and he flounders as he is faced with a decision on taste just as he would flounder when confronted with the necessity to make a decision on moral matters. Elck *is* this way, as Bruegel has told us over and over again (fig. 19). But in comparison with the power that radiates from the face of the artist, the meaning of this other figure is decidedly secondary in importance. That face is the face of a genius; exalted and full of a *furor divino*, but also deeply furrowed by the experience of looking through things and people; grim, but determined to bypass nothing; following his own lodestar, speaking his own mind, and addressing those who have eyes to see and a mind open enough to listen to unpalatable truths about themselves—thus Pieter Bruegel the Elder, the so-called "Peasant-Bruegel," anno Domini 1569 and still anno Domini 1990.

Figure 37. Bruegel.
THE HORSE TRADER.
c. 1560–65.
Drawing, 7¾ × 5¾".
Städelsches Kunstinstitut,
Frankfort

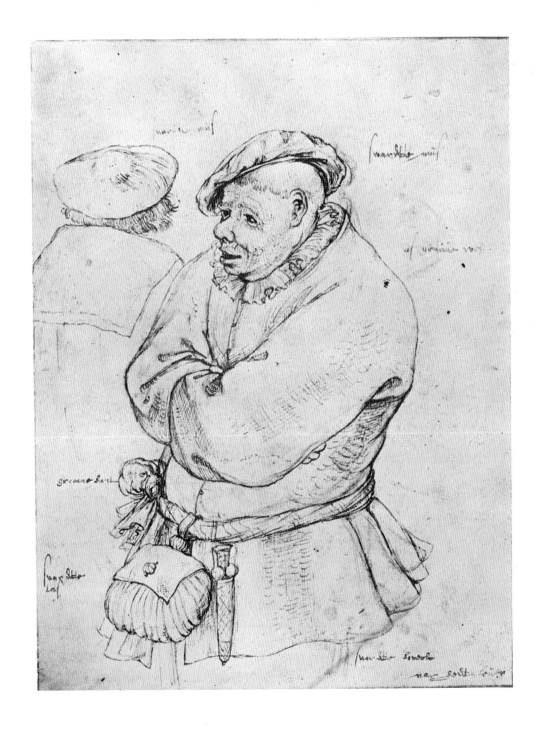

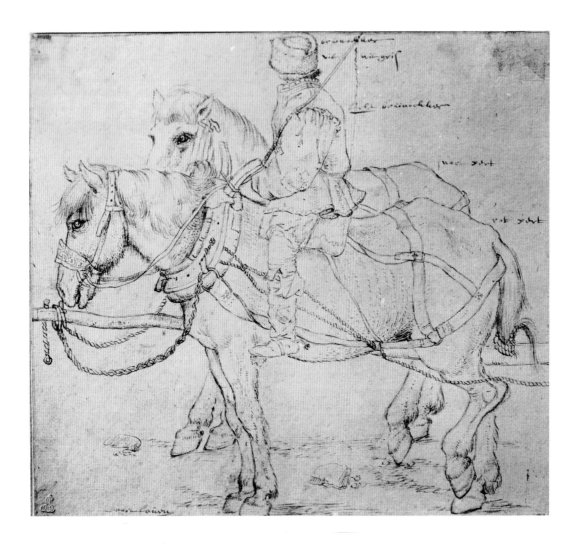

Figure 38. Bruegel.
A TEAM OF HORSES. c. 1560–65.
Drawing, 6½×7¼″.
Albertina, Vienna

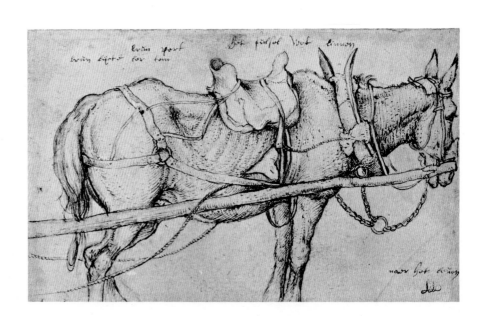

Figure 39. Bruegel.
A MULE IN HARNESS. c. 1560–65.
Drawing, 3¾×6¼″.
Collection Count Antoine Seilern,
London

Figure 40. Bruegel.
THE PAINTER AND THE CONNOISSEUR.
c. 1565–68.
Drawing, 9¾ × 8½".
Albertina, Vienna

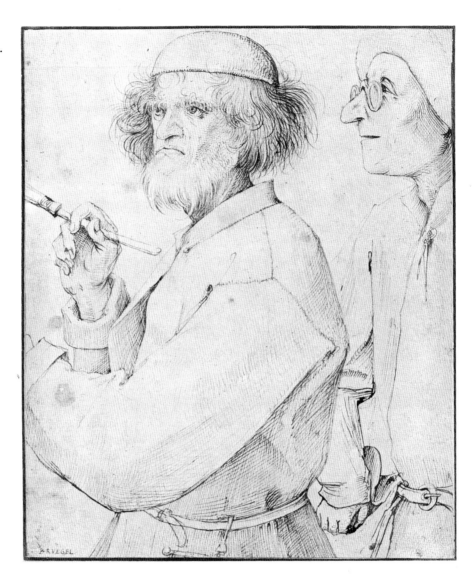

BIOGRAPHICAL OUTLINE

c. 1528–30 Born in Breda(?).

Before 1550 Pupil of Pieter Coecke van Aelst in Antwerp (?).

1550 Together with Pieter Balten(s), works on an altarpiece in the shop of Claude Dorizi at Mechelen (Malines).

1551 Enters the painters' guild at Antwerp.

1552–53 By way of France (Lyons), travels to Italy (Rome, Naples, Reggio di Calabria, Messina, perhaps Palermo). Collaboration with Giulio Clovio.

1554 Returns via Switzerland.

1555–63 Resides in Antwerp; begins to make drawings for the etcher and publisher of prints Hieronymus Cock, an activity continued into the Brussels years. Friendship with Abraham Ortelius.

1562 Visits Amsterdam.

1563 Moves to Brussels; about Easter marries Mayken, daughter of Pieter Coecke van Aelst and Mayken Verhulst.

c. 1566–68 Is commissioned by the City Council of Brussels to make one or more paintings (?) representing the digging of the Brussels–Antwerp Canal.

1569 September 9: Dies in Brussels and is buried in Notre Dame de la Chapelle.

COLORPLATES

LANDSCAPE WITH THE
PARABLE OF THE SOWER

Signed and dated 1557
Canvas, 29⅛×40⅛"
Timken Art Gallery, San Diego, California

The parable of the sower is told by Christ in Matthew 13:3–8, and explained by him in the same chapter, verses 18–23; at that time "great multitudes were gathered together unto him, so that he went into a ship, and sat; and the whole multitude stood on the shore." The present picture shows Christ in the boat and the multitude on the shore in the right middle ground, and the parable itself in eloquent detail in the foreground. The elderly but sturdy sower walks toward us with a characteristically animated gait; two sacks with seeds stand behind him on the ground. The seeds falling "by the way side" are immediately picked up by birds (under the tree); the thorns that are to choke other seed are waiting in the left corner; the seed that falls on stony ground springs up fast but, being rootless, will wither away, is clearly depicted near the center; the good soil that "brought forth fruit, some an hundredfold, some sixtyfold, some thirtyfold" lies farther back near the cottages.

The composition of the picture is strongly reminiscent of the series of the "Large Landscapes," particularly, in reverse, of the *Solicitudo Rustica* (fig. 41) with its tree coulisse on one side, the huge mountains in the distance on the other side, the river flowing diagonally by a city and toward a vast bay, the buildings down in the valley below the high foreground, the scarcity of foreground figures on one side. This series of prints was made after Bruegel's designs during the late 1550s and about 1560; the San Diego painting may well be based on a drawing made by Bruegel in preparation for, or at least contemporary with, that great group of world panoramas

(see also fig. 29). But for the *Landscape with Christ Appearing to the Apostles* of 1553 (fig. 7), this picture is the earliest dated painting by Bruegel; it marks an important step in the direction of the landscapes of the 1560s. That it enjoyed considerable reputation is proved by early copies. The spelling "Brueghel," found in its signature, was abandoned by the master in his later works but readopted by his sons.

Figure 41. Jan and/or Lucas a Duetecum after Bruegel.
SOLICITUDO RUSTICA. c. 1555–60.
Etching and engraving, 12⅝×16¾"

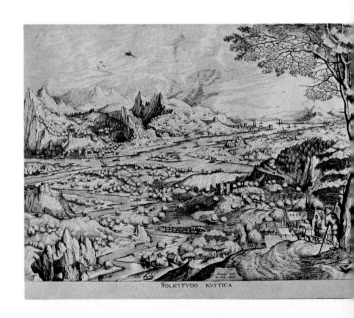

SOLICITVDO RVSTICA

LANDSCAPE WITH THE FALL OF ICARUS

Datable c. 1558(?)

Canvas, 29×44⅛″

Musées Royaux des Beaux-Arts, Brussels

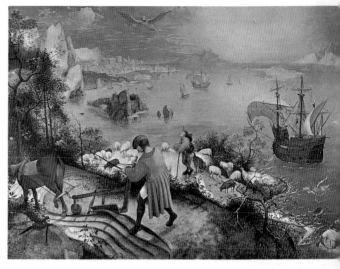

Figure 42. Bruegel. THE FALL OF ICARUS. c. 1558(?).
Panel, 24¾×35½″.
Collection D. M. van Buuren, New York and Brussels

The extremely difficult question of the authenticity of this unsigned and undated picture, particularly as it is affected by the existence of an equally undocumented smaller version in the D. M. van Buuren collection (fig. 42), must remain unanswered and even undiscussed here. The differences between the two paintings are small and do not seem to contribute to a clear solution of the problem. In the museum version, the figure of Daedalus, which appears in the sky (left of center) in the Van Buuren picture, is lacking; but although it is iconographically required (see below) and its omission therefore may seem to cast doubts on the Brussels version, it must be remembered that the latter was probably transferred from panel to canvas in the nineteenth century, and that the figure of Daedalus may originally have been depicted in it. The setting sun is not visible in the Van Buuren version, in which the left and right edges are significantly less extended than in the Brussels canvas.

There is very little doubt that the composition is Bruegel's, even if both extant versions should turn out to be copies, or either one an unsatisfactorily preserved original, but the question regarding its place in Bruegel's development (some date it very early, others very late) must remain open under these circumstances.

It is the only painting by Bruegel with a mythological subject, and the subject is not a mere excuse for a landscape. Perhaps one may say this with regard to the early Bruegel design which is known through an etching posthumously signed and dated 1553 (fig. 43), and also through a print, probably of 1565, from the series of ships; in the former, the story is given as an illustration of the necessity of moderation (*inter utrumque vola*), in the latter simply as an attribute of the sea (other prints from the same professionally maritime series—see fig. 50—contain the stories of Arion and of Phaëton inserted in the same spirit). But

the painting, though uniquely showing Icarus already submerged in water but for his legs, has, in fact, the story as told by Ovid (*Metamorphoses* VIII, 217–22) written all over it: "[Beneath], someone catching fish with his tremulous rod,/the shepherd leaning on his crook, or the ploughman on his handle,/saw them and wondered how they could take to the air/and thought they must be gods. Already, on the left,/they passed by Samos, Juno's isle, and by Delos and Paros;/and on the right, by Labinthos and Calymne, fruitful in honey. . . ." Bruegel apparently took only one major

Figure 43. Anonymous etcher after Bruegel.
LANDSCAPE WITH THE FALL OF ICARUS. After 1553.
Etching, 10¾×13⅜″

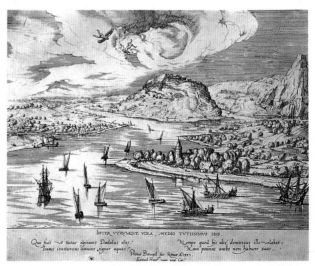

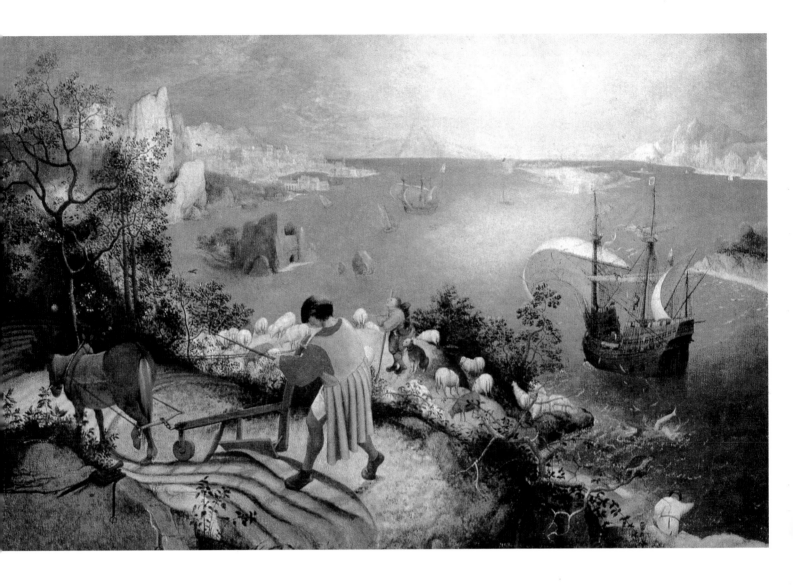

liberty with this text: he made only the central figure (the shepherd) look up—Daedalus must indeed have been visible there in the sky—while the fisherman and the ploughman are unconcernedly going about their business. This marvelous feature is also known from a German proverb, which was current by 1604 at the latest; it says that "no plough is stopped for the sake of a dying man." The same sentiment is echoed in W. H. Auden's beautiful passage on Bruegel's picture:

In Brueghel's *Icarus*, for instance: how everything turns away
Quite leisurely from the disaster; the ploughman may
Have heard the splash, the forsaken cry,

But for him it was not an important failure; the sun shone
As it had to on the white legs disappearing into the green
Water; and the expensive delicate ship that must have seen
Something amazing, a boy falling out of the sky,
Had somewhere to get to and sailed calmly on.

Icarus' flight occurs early as a paradigm of folly; whether Bruegel saw it in this light when he painted this picture, or whether he was still concerned with pointing out, in the Ovidian tradition, that moderation and the golden mean (*medio tutissimus ibis*) are essential to the good life, is difficult to make out; the latter interpretation seems to be more probable and would also speak for a relatively early date of the composition.

COLORPLATE 3

THE FIGHT BETWEEN CARNIVAL AND LENT

Signed and dated 1559
Panel, 46½ × 64¾"
Kunsthistorisches Museum, Vienna

In the year 1558, Bruegel's friend and publisher Hieronymus Cock, had brought out an etching by Frans Hogenberg (fig. 44) which illustrates *The Fight Between Carnival and Lent,* an allegory of the abrupt change from the exuberant enjoyment of life customary immediately prior to the Lenten season, to the austere mood of the subsequent period. Hogenberg's print is inscribed: "The fat carnival evening with all its guests is seen here fighting the meagre lent"; it is the first visualization of this contrast as a regular duel between personifications of Carnival and Lent (a painting by Hieronymus Bosch preserved in copies or adaptations does not stress this idea), and it undoubtedly inspired Bruegel's painting of 1559.

The objection to the excesses of the "devil's work" of Carnival—its name, derived from *carnem levare,* indicates the abandoning of all those good things— was old, and Bruegel's satire is primarily directed against the folly of overindulgence drastically expressed in the rotund figure of Carnival's rep-

Figure 45. Pieter van der Heyden after Bruegel.
"WEDDING OF MOPSUS" (THE DIRTY BRIDE). 1570.
Engraving, 8⅝ × 11⅛"

Figure 46. Anonymous artist after Bruegel.
URSON AND VALENTINE. 1566.
Woodcut, 10¾ × 16¼"

resentative riding on an equally massive wine barrel and brandishing a heavily laden spit in the direction of Lent; every conceivable characteristic of gluttony is displayed around and behind him, everybody indulges in eating, drinking, dancing, lovemaking, and theatrical performances, and only the beggars and cripples are left to their misery. On the other side, Lent is represented by a lean hag warding off Carnival's spit with a shovel on which two very meagre herrings are virtuously lined up; her entourage nibbles on sober fare and refrains from belligerence in contrast to Hogenberg's violently aggressive crowd. Good

Figure 44. Frans Hogenberg.
THE FIGHT BETWEEN CARNIVAL AND LENT. 1558.
Etching, 12⅞ × 20⅜"

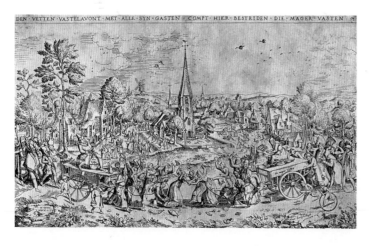

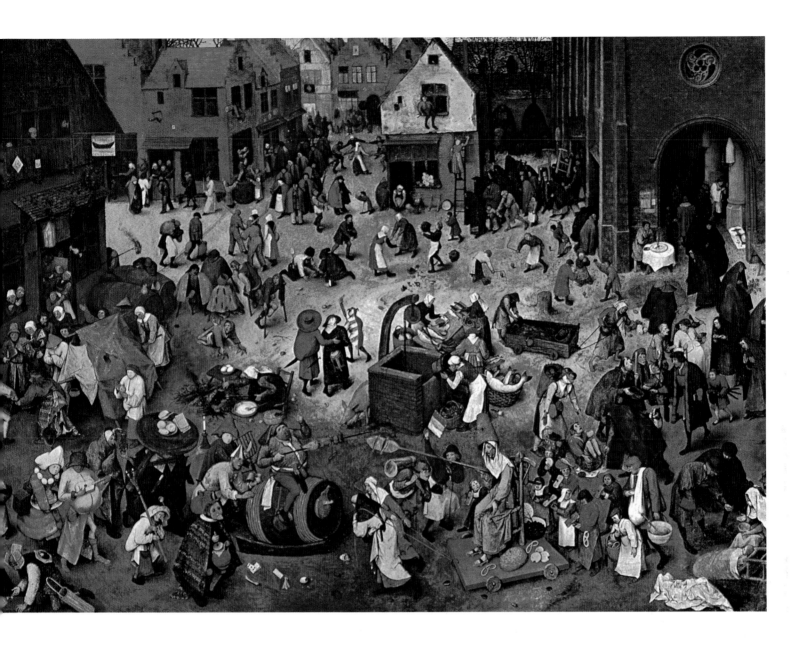

deeds are performed everywhere in this section, in-
cluding burial of the dead (the corpse of a man in
the cart drawn by the old woman has been overpaint-
ed), people give alms, buy candles, and go to church;
even the children near the church play a game which
may in this case suggest virtue, albeit an enforced
virtue: the top can symbolize the necessity of being
beaten (chastised) in order to avoid downfall.

But it is important to realize that Hogenberg and
Bruegel do not really take sides in this battle. Virtue
is apparently all on the side of Lent as far as actions
are concerned, but the battle has not been decided;

furthermore, Bruegel's characterization of Lent (her
model was a Bosch witch), and many of her followers,
is clearly not much more sympathetic than that of
Carnival and his cohorts. The two sides balance each
other in composition as well, and the prominent center
group of the picture, carefully isolated and fully set
off against the ground, consists of a couple seen from
behind and led into the background by a fool; the
woman carries a useless, unlighted lantern on her
back. Protestants were often accused of promoting
vice and folly by denigrating good works; if Bruegel
intended to allude to them as followers of Carnival,

the Catholic side does not fare much better, and the unenlightened couple in the center sums it up nicely: they are *all* fools. In 1567, Ortelius was to speak of the "Catholic evil, Protestant fever, and the Huguenot dysentery."

The detail shows the border line between Carnival and Lent in the right middle ground and distance: a dance, and a game involving the throwing and breaking of pots belong to the former; the bakery is "neutral," since it produces pancakes as well as pretzels. A woman sells fish for Lenten fare; in front one sees part of the well. On the right, the cart contains the dead man, now overpainted, and the children spin tops (see above); a procession of nuns and other

people emerge from the church, before which others are kneeling in prayer. The fool of the center group is visible in the lower left corner.

The plays performed on the Carnival side are popular masques: "The Dirty Bride" (in front of the inn, foreground) and "Urson and Valentine" (farther back, in front of the corner house). Both were represented again by Bruegel later on: the Dirty Bride exists in the master's original drawing on a wood block which shows the beginnings of cutting (Metropolitan Museum, New York), and in an engraving by Pieter van der Heyden of 1570 (in reverse, fig. 45; with wrong identification as the "*Wedding of Mopsus and Nisa*"), and Urson and Valentine in an executed

Figure 47. Bruegel(?). THREE HEADS. c. 1560(?).
Panel, $9\frac{3}{4} \times 13\frac{1}{4}''$.
Royal Museum of Art, Copenhagen

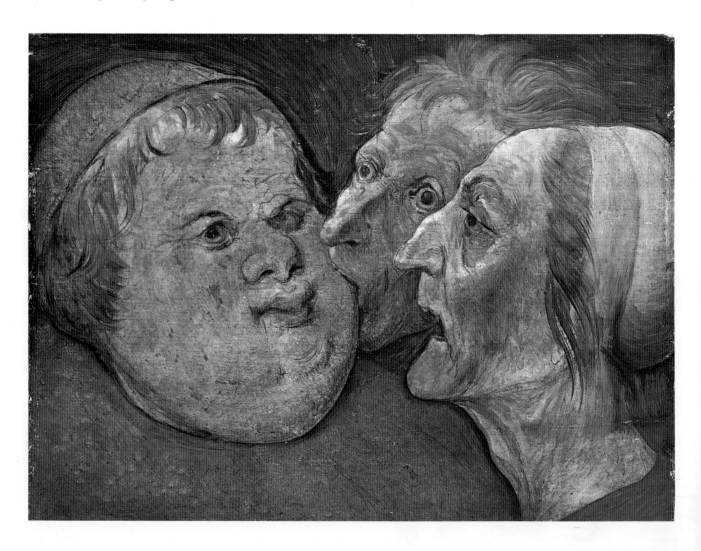

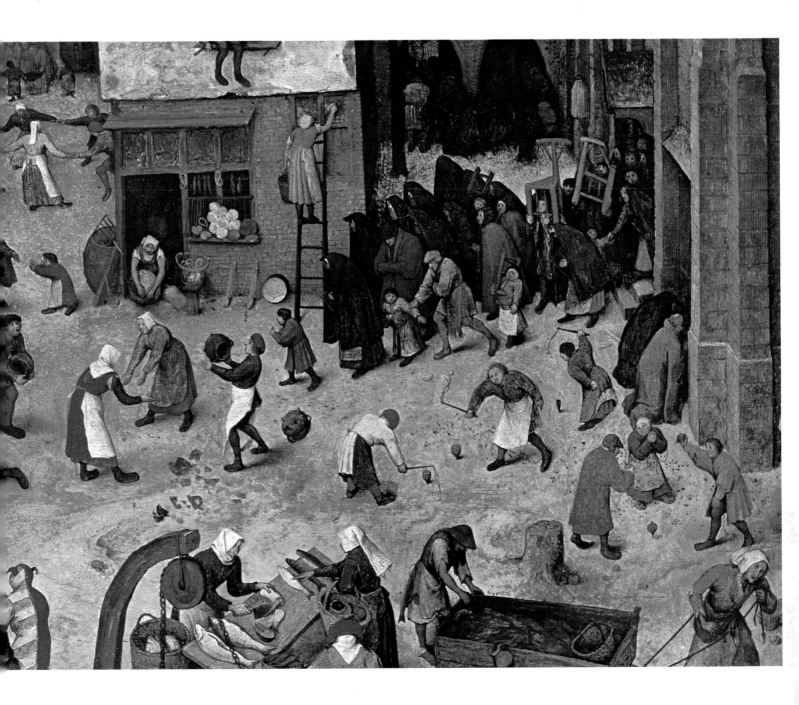

woodcut of 1566 (fig. 46; probably the companion piece of the Dirty Bride); in the background of *Urson,* one can see admission fees being collected.

A drawing in the Curtis Baer collection in New Rochelle, New York, seems to contain a study for the woman seen from behind near the fish stall.

The Royal Museum in Copenhagen preserves an enigmatic small panel with *Three Heads* (fig. 47), an amiable fat one and two grotesque lean ones, one of which takes a desperate bite out of the big cheek of the former. The attribution of this picture to Bruegel has often been doubted but certainly deserves close reconsideration.

COLORPLATE 4

THE FIGHT BETWEEN CARNIVAL AND LENT

(detail)

NETHERLANDISH PROVERBS

Signed and dated 1559
Panel, 46 × 64⅛"
Staatliche Museen, Berlin

The Netherlandish language of Bruegel's time was even richer in proverbs than it is today—which means a great deal—and Netherlanders have always been fond of such repositories of human wisdom. Erasmus' *Adagia* were first published in 1500 and contained about 800 items; they conveyed the blessings of the greatest humanist upon a popular collecting craze and were soon reprinted with a vastly increased number of entries. Proverbs have a way of unmasking human folly, and Erasmus was magnetically drawn to this aspect of them as Bruegel was to be. Proverbs also have a way of being ambiguous, multifaceted, iridescent, and Bruegel shared with many of his contemporaries a distinct preference for these properties—the typically Mannerist preference for the ambiguous, the enigmatic, the hidden meanings, which our own age has rediscovered and awarded such wide (and often misguided) acclaim. Several of the proverbs represented in the Berlin picture have disappeared from usage; others are ambivalent; others again may intrigue us primarily because they have no clear English equivalent. One has to *know* that a "pillar biter" is a hypocrite and that she who puts a blue hood over her husband makes him a cuckold; and here one fills the well after the calf has been drowned in it instead of locking the barn door after the horse has been stolen.

While the accumulation of proverbs was a widespread literary device and had also been essayed, on a relatively restricted scale, in visual representations, Bruegel's picture of 1559 is the first that united about one hundred of them in one comprehensive spatial setting, a true "proverb country," even though this setting is more psychologically than realistically plausible. That there is a convincing "composition" here—a miracle considering the task the artist set

himself—is perhaps due more to the subtle and amazingly successful color scheme than to the distribution of figures and architecture, for which Bruegel may have availed himself of the precedent set by Hieronymus Bosch in a *Last Judgment* engraved by Hieronymus Cock. The combination of strong reds and blues marks decisive points of main structure throughout, and these set the pace from the iconographic point of view as well, since they demarcate scenes of consummate folly and sin. The center is dominated by the "blue hood," placed by a woman over her husband, from which the picture derived its title for many years; its meaning extends beyond the specific one of making a cuckold of a husband, and indicates betrayal and cheating in general: the blue color often stands for cheating as well as for folly, while red can stand for sin and impudence. The blue, foolish, topsy-turvy world is prominently displayed on the left; a red scoundrel drastically expresses his contempt of it; the Netherlandish word *verkeerd* (like its German equivalent *verkehrt*) stands for both upside down and wrong. Christ, in a blue garb, is the victim of the treachery and folly of a monk who has put him on a red chair, and mocks Him by putting a flaxen beard on Him. The power and convincingness of Bruegel's comprehensive view of mankind as endlessly involved in foolish actions is poignantly documented by a comparison with a woodcut by Sebald Beham which lists a large number of follies in its caption but illustrates only two of them, and with the surviving half of Frans Hogenberg's engraving *The Blue Hood* (fig. 48), which illustrates many of them but in a disjunct, isolated fashion. Nevertheless, this engraving, which was almost certainly produced in 1558, was an important source for Bruegel, the more so as it puts the blue hood in a very prominent posi-

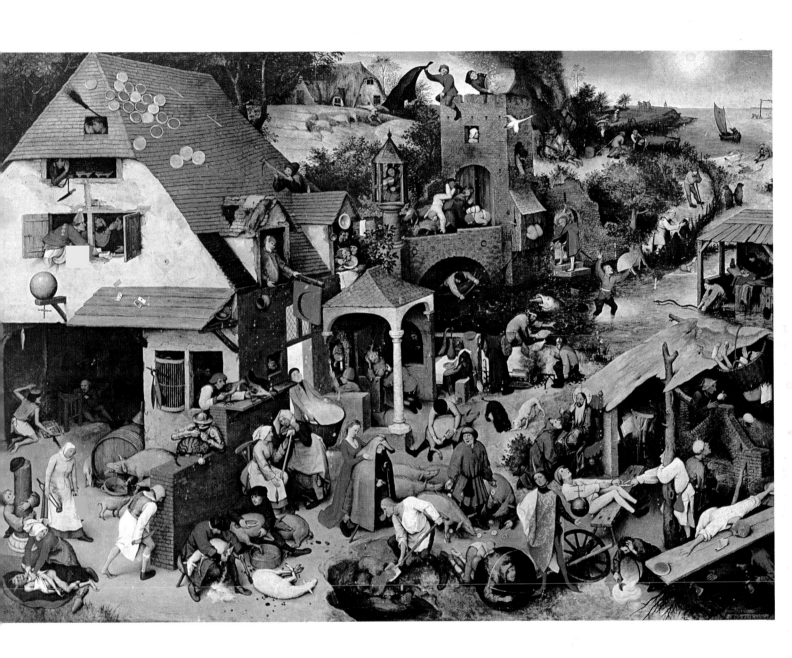

tion. The "Proverb Island" in Rabelais' *Pantagruel*, in which proverbs are represented in accumulative actions similar to Bruegel's, is the most famous literary parallel of the Berlin painting, and certainly the most congenial one; but it was not published until 1564, and therefore cannot have been Bruegel's source.

How much Bruegel thought of this accumulation of proverbs primarily as a parade of human folly he indicated not only by the prominence of the upsidedown "world," but also by the characterization of his actors. Already in this early work, most of his people exhibit the blank, round-eyed faces which in conjunction with their frenzied, seemingly senseless activity convey that expression of pathetic futility, that automaton-like forlornness which was to touch upon unforgettable tragedy in his most mature works such as *The Parable of the Blind* of 1568 in Naples (colorplate 36), of which the present picture contains an inconspicuous germ far away in the background.

The detail plate shows: a man bites into a pillar (he is a hypocrite); a woman binds a devil on a pillow (proverb not clear); a woman carries water in one hand, fire in the other; a man cooks a herring for the sake of the roes; an empty herring ("more than an empty herring" means "more than meets the eye"); a man sits in the ashes between two stools; the sow removes the spigot; a man, put in harness, bangs his head against the wall; a man, armed to the teeth, puts a bell on a cat; a man speaks out of two mouths; much crying about little wool; one shears the sheep, another the pig; one holds the distaff, the other spins (they spread gossip); a man carries daylight in a bottomless basket; a man lights a candle for the devil; one confesses to the devil; a man acts as an earblower (prompting somebody); the blue hood (see above); one fills the well after the calf has been drowned (see above).

Figure 48. Frans Hogenberg.
THE BLUE HOOD (fragment). 1558.
Engraving

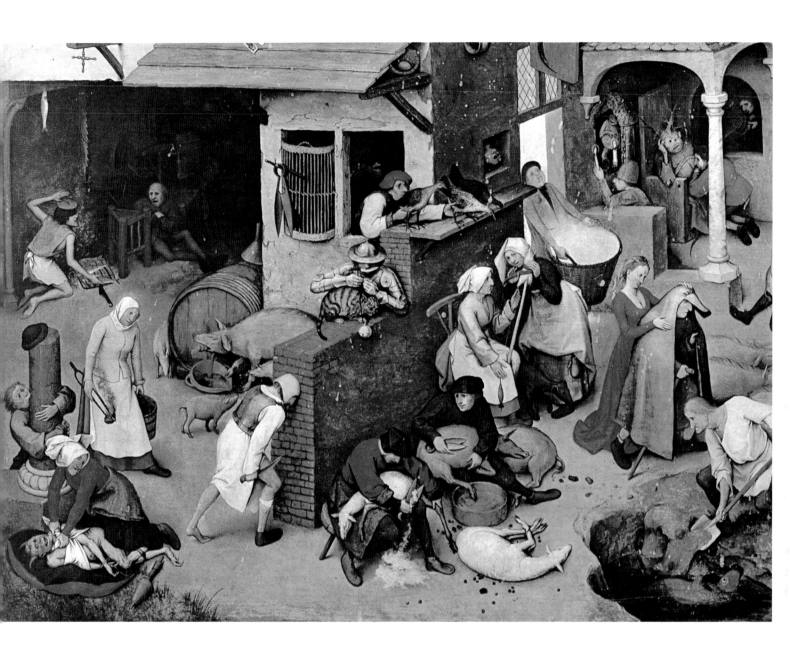

COLORPLATE 6

NETHERLANDISH PROVERBS

(detail)

CHILDREN'S GAMES

Signed and dated 1560
Panel, 46½ × 63⅜"
Kunsthistorisches Museum, Vienna

The subject of children's games occurs in book illumination as well as in tapestries and prints before Bruegel, but his interpretation is based on an entirely different premise. In Bruegel's Vienna painting of 1560, children stand for adults, and it is the folly of adults that is chastised in a guise which makes no effort to disguise: these are children only by size and (partly) by dress. When five of them pull the hair of a single victim and when they kill flies, they act more savagely than normal children would; but that is not all. The trundling of a hoop and the whipping of a top become frantic efforts; among the hundreds of children's faces that this picture contains, there is not a single one that expresses childlike enjoyment of what the body is doing in its compulsive action; the gnomelike figures resemble puppets manipulated by an invisible hand exactly as do Bruegel's adults. This is a panorama of folly rather than of childhood, and if there is something to the (shaky) theory that this painting was planned as an allegory of *Infantia*, to be supplemented by representations of other *Ages of Man*, it is difficult to see how it could have looked less forbidding than its companion pieces.

The setting for this display of about eighty identifiable games is of extraordinary clarity, and was undoubtedly influenced by Italian city views of the type that had started with Piero della Francesca, and culminated in the sixteenth century in the woodcuts illustrating the works of Sebastiano Serlio. A dense network of figure groups, arranged in horizontals and diagonals, has been inserted in the vast playground defined by the architectural elements, and given variety by a rich but judiciously devised alternation of sharply defined color areas in the costumes, with a strong preponderance of red and blue, set off against the light brown and green of the ground. The top of a central pyramid, the sides of which are emphasized by the house wall and the diagonal part of the red fence on the left and the long beam and the group of boys playing leapfrog on the right, is marked —in the near-exact center of the picture—by a child bride procession seen strictly from the front. This group deliberately echoes the large pyramid in a small one which consists of the two children carrying a basket, and a companion of the "bride" clad in brilliant red; and this "keystone" is indeed the key to the picture in the sense that children here imitate adults.

It is a relief to escape, as it were, from the frantic actions of the main part of the picture to the brilliantly and sketchily painted landscape at the upper left which increasingly frees itself from its human burden, and in this way prefigures Bruegel's view, so strongly emphasized in some of his later works, that nature is the one redeeming feature of a world dominated by the folly of man.

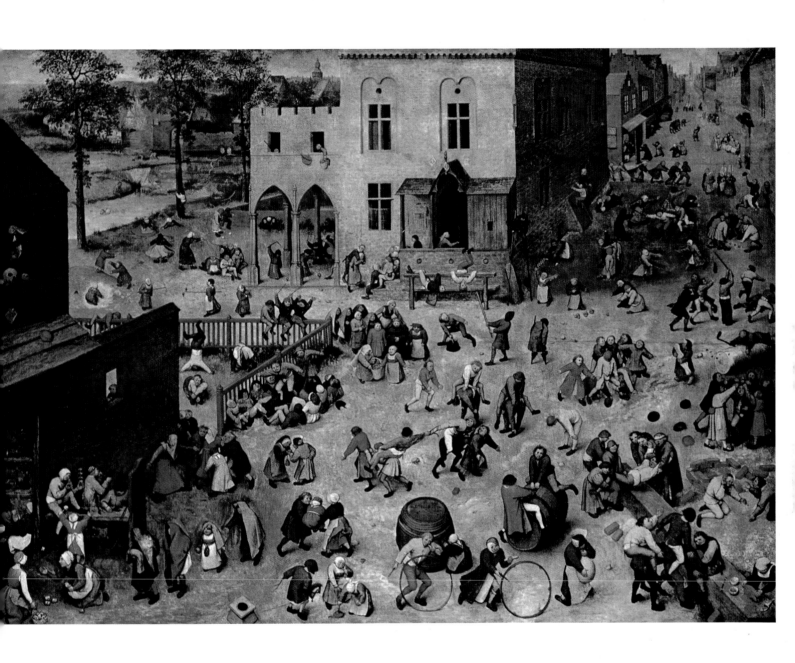

COLORPLATE 8

VIEW OF NAPLES

Datable 1560–62
Panel, 15¾ × 27⅜"
Galleria Doria Pamphili, Rome

The *View of Naples* is not signed or dated but has been almost universally accepted as a work of Bruegel. However, the question of its place in the master's painted *œuvre* is hard to decide—just as it is in the case of *The Fall of Icarus,* thus emphasizing the fact of the basic otherness of each of his paintings, and the breakdown of customary criteria of defining "development" in his art. A comparison with *The Storm at Sea* in Vienna (colorplate 40), the only other seascape by Bruegel, seems to point to an early date for the *View of Naples,* but the *Storm* is not signed or dated either, and its assignment to Bruegel's late phase remains hypothetical. On the other hand, the subject of the present picture does speak for a considerably earlier date. Bruegel must have seen Naples during his Italian sojourn (1551–53). He was in Rome, southern Italy, and Sicily, and in 1561 Hieronymus Cock published a print after a drawing by Bruegel which minutely describes a battle in the Straits of Messina (fig. 49) and for which a preliminary drawing by Bruegel, minus the ships and most probably made on the spot, was later owned by Georg Hoefnagel; the two compositions have much in common, even apart from the placing of the volcanoes (Vesuvius and Aetna, respectively) in the same positions. A date of about 1560–62 for the Doria painting seems reasonable to assume.

The action in this painting is hard to define. It has sometimes been thought to consist of a naval skirmish, comparable to that shown in the print of 1561, and some firing from several of the ships can indeed be observed, but its meaning remains obscure. It must be remembered that the presence of ships of all sorts was *de rigueur* in any map of a harbor, and can indeed be noted on maps of Naples from that time (1560, 1566). And these maps also show how much Bruegel

Figure 49. Frans Huys after Bruegel.
NAVAL BATTLE IN THE STRAITS OF MESSINA. 1561.
Engraving, 17¼ × 28⅜"

deviated from the topographical facts of the city; while some landmarks are unmistakable (Castel dell' Ovo, Torre San Vincenzo, Castel Nuovo), the near-perfect circular shape of the jetty is Bruegel's own elegant reinterpretation of a much less attractive rectangular one.

That Bruegel was a great connoisseur of ships is evident from the magnificent series of eleven designs engraved by Frans Huys and published in 1565. In each of these prints, one or more ships of all kinds are rendered with extraordinary accuracy, sometimes in quiet positions and environments, sometimes in brisk movements and agitated seas, occasionally enriched with a mythological subject. The fact that the three-master in the left foreground of the *View of Naples* is an almost exact mirror image of that shown in one of the print series (fig. 50) has rightly been cited as an additional criterion of Bruegel's authorship of the painting.

Figure 50. Frans Huys after Bruegel.
MAN OF WAR. c. 1560–65.
Engraving, $12\frac{5}{8} \times 9\frac{3}{4}''$

THE FALL
OF THE REBEL ANGELS

Signed and dated 1562
Panel, 46 × 63¾"
Musées Royaux des Beaux-Arts, Brussels

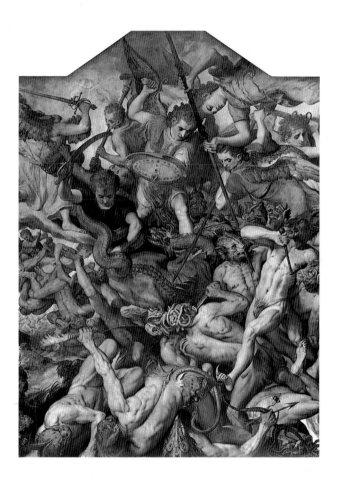

Figure 51. Frans Floris.
FALL OF THE REBEL ANGELS. 1554.
Panel, 10′ 1¼″ × 7′ 2″.
Royal Museum of Fine Arts, Antwerp

The Fall of the Rebel Angels was painted in the same year as the *Mad Meg*. With *The Triumph of Death*, which is undated but most probably belongs in the same period, these form a great triad of works in which Bruegel continued the fantastic trend that had culminated in the works of Hieronymus Bosch in the first two decades of the sixteenth century, and which gained him the reputation of a "second Bosch" at an early date. Bosch had already given a brilliant representation of the fall of the rebellious angels in the *Paradise* wing of the large eschatological altarpiece painted in 1504, and now in the Vienna Academy of Fine Arts; in the present picture, Bruegel concentrated on this subject in a large oblong panel, about the original location of which we know—as usual—nothing. Eight years earlier (1554), Frans Floris had painted a huge upright altarpiece of the subject for the Altar of the Fencers in the Cathedral of Antwerp (fig. 51), and while its Italianate nudes are far removed from Bruegel's conception, its monsters may have influenced a few of the latter, and the same is true of some forms in Dürer's woodcut of the *Apocalypse* series (1498). Saint Michael and his helpers are engaged, with supreme confidence, in the one-sided battle against the falling angels and their sinful cohorts; the elegantly armored, extremely slender saint is pushing down the dragon of the Apocalypse with such vigor that its crowned heads are already close to the bottom of the panel, while its tail is still lashing at the sun; Saint Michael's two main helpers completely dominate the two upper lateral areas with their large unencumbered bodies and the vast white of their habits, so that the throngs of weird forms and colors below merge in inarticulate defeat. The strains of victorious angel musicians—siblings of those blowing the trumpets in *The Last Judgment* designed by

Bruegel as early as 1558 (fig. 2)—are supplemented in a pathetic effort at counterpoint by a rather daring fallen angel at the lower right and a comically frustrated one at the lower left margin. Bruegel never forgets, however, that sin *can* be attractive in its own weird way; witness the extraordinarily beautiful butterfly wings of the creature below Saint Michael, displayed in a very prominent position. The coloristic characterization of the defeated throng vies with that of the hellish monsters of the *Mad Meg* in its wealth of shades, of *changeant* tints and poisonous hues, together with a superb display of skill in defining textures—slimy, hairy, prickly; against the blinding sun disk above, the light tints of the angels—cool blue, rose, golden yellow, white—stand out in medieval purity.

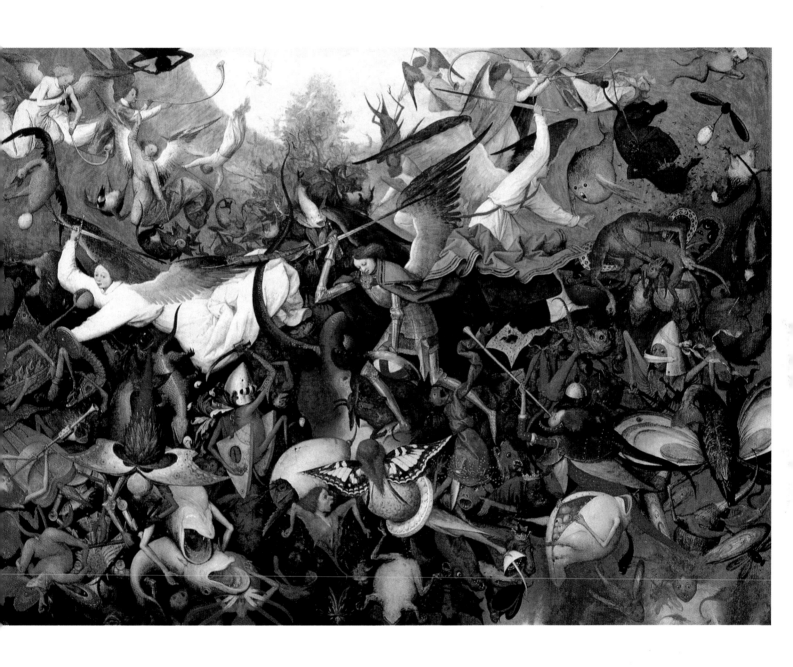

MAD MEG (DULLE GRIET)

Signed and dated 1562(?)
Panel, 45¼ × 63⅜"
Musée Mayer van den Bergh, Antwerp

The *Mad Meg* is perhaps the most Boschlike composition by Bruegel, at least at first glance; there are monsters, demons, a wild *mêlée* of ruins, ships, weird towers and caves, and conflagrations, wherever you look. But the resemblance fades somewhat as one observes more closely. First of all there is a truly predominant figure, the Dulle Griet or Mad Meg, who strides forward to the left with a powerful gait quite alien to Bosch's imagination. She is worse than Hell itself; in fact, she has just emerged from Hell *victorious*, laden with loot, and is going after other conquests which we can only imagine. While other, minor hags crowd the bridge which Mad Meg has just left behind, in a wild contest for the coins that a truly Boschlike monster sitting on the roof of a house shovels down to them from his behind, Mad Meg strides on in contemptuous isolation, with the wild stare of the true fanatic, armed for combat, a formidable shrew, who has reduced the monsters of Hell to puny little nincompoops brandishing their armor in pathetically harmless gestures. She is greed personified, a truly capital sinner, but in contrast to the designs in which Bruegel had just previously represented each capital sin in similarly predominant figures (in the series of the "Vices"), she is anything but an allegory.

Beside greed, many other sins populate this Hell. The meaning of some of the monsters, animals, birds, and objects is just as difficult to identify as it is in paintings by Bosch, but gluttony, vanity, and unchastity are more or less clearly characterized. Most impressive is Bruegel's vision of Satan as an enormous whalelike demon, still reminiscent of the traditional "Mouth of Hell" but now conceived as an impassive tool rather than a violent agent of destruction—so impassive and stupid in fact that its horrible face and horrified eye have themselves become the victim of a special brand of parasites. This concept had already been fully developed in a composition known to us from Bruegel's original drawing in the Ashmolean Museum, Oxford, and from an engraving of 1556 published by Hieronymus Cock, strangely without Bruegel's name. Here that huge, stupid head is supposed to frighten Saint Anthony out of his wits, but is doomed to impotence as are all his ludicrous companions; it is invaded by parasites as woefully as is its counterpart in the *Mad Meg*, which is equally ignored by the main actor in that composition.

The Boschlike character of the picture is quite evident from the detail; its monsters and its magnificent coloristic use of the conflagration are familiar from the older master's representations of Hell, particularly of that on the right wing of the *Haywain* triptych in the Prado in Madrid. But everything has taken on a new element of vigor and sturdiness under Bruegel's hands which perhaps cannot vie with the poetic charm and frailty of Bosch's interpretation, but produces a level of reality which fits the different character of Bruegel's entire picture to perfection: the more three-dimensional forms of the buildings and other objects such as the big bowl with the soldiers, the bell and the flag, the soldiers themselves and the monsters, make them appear more absurd, more foolish than any of Bosch's, and more appropriate to the protagonist of the painting, which is, after all, not Satan but Mad Meg.

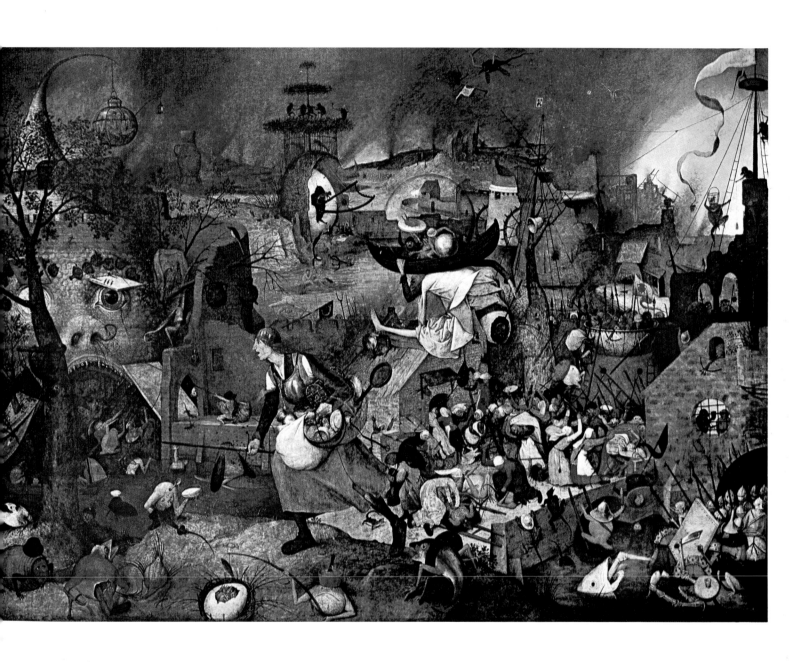

THE TRIUMPH OF DEATH

Datable c. 1562
Panel, 46 × 63¾"
The Prado, Madrid

The large *Triumph of Death* is neither signed nor dated but its attribution to Bruegel cannot be doubtful, and its date cannot be far from the *Mad Meg* and *The Fall of the Rebel Angels*, that is, in or about 1562. The subject is a most ingenious synthesis of the two concepts of the Triumph of Death and the Dance of Death as they existed in the late Middle Ages; Bruegel certainly knew important examples of each, such as the frescoes in Pisa or Palermo for the former, and Holbein's woodcuts or the Basel Cemetery cycle for the latter. But to Bruegel, death is the result of sin rather than of ordinary human frailty; and while he and Holbein (fig. 52) belong together in their representations of Death as an agile skeleton, Holbein's consistent one-to-one relationship (each individual person, or rather, each representative of his rank and profession, with his appropriate death, in the tradition of earlier series of this kind), and his method of showing Death as mocking his victim and taking him by surprise are in Bruegel restricted to a small selection. On the whole, it has been replaced by vast armies of skeletons fighting in phalanxes and overwhelming large crowds of nondescript human beings, as well as by skeletons simply working as executioners such as we see in the unforgettable scenes in the right background. Conflagrations and catastrophes of all kinds add to the impression of this picture as a *Theatrum Mundi* under the direction of the prince of total annihilation.

The more specific cases are shown in the foreground, but even here the similarity to Holbein's cycle is limited. Death as a single skeleton is indeed here closely related to the emperor and the cardinal as he is in Holbein's woodcuts (fig. 52); to the emperor the skeleton mockingly presents the hourglass; he derisively feigns to uphold the cardinal as he slumps down in death. But Holbein's emperor has committed no identifiable sin whereas Bruegel's is clearly indicted as a greedy miser—a second skeleton illustrates this—and the same sin can be imputed to the cardinal, who quite exceptionally is clad in blue (a suggestion of cheating?); to him Holbein did attribute a sin—but a sin only in the eyes of a Protestant, namely the sale of indulgences. The only other important specific detail, this time involving futile resistance, is given in the lower right corner, where a lansquenet, rising from a dining and gambling table, makes a bravado's gesture of defense while his mate crawls under the table and a dressed-up skeleton is having fun with the wine cooler; another skeleton plays a mock coda on his lute for the music made by a pair of lovers oblivious to the entire outside world. All these have earned the "wages of sin."

Figure 52. Hans Holbein the Younger.
THE CARDINAL, from the *Dance of Death*. c. 1525.
Woodcut, 2½ × 2″

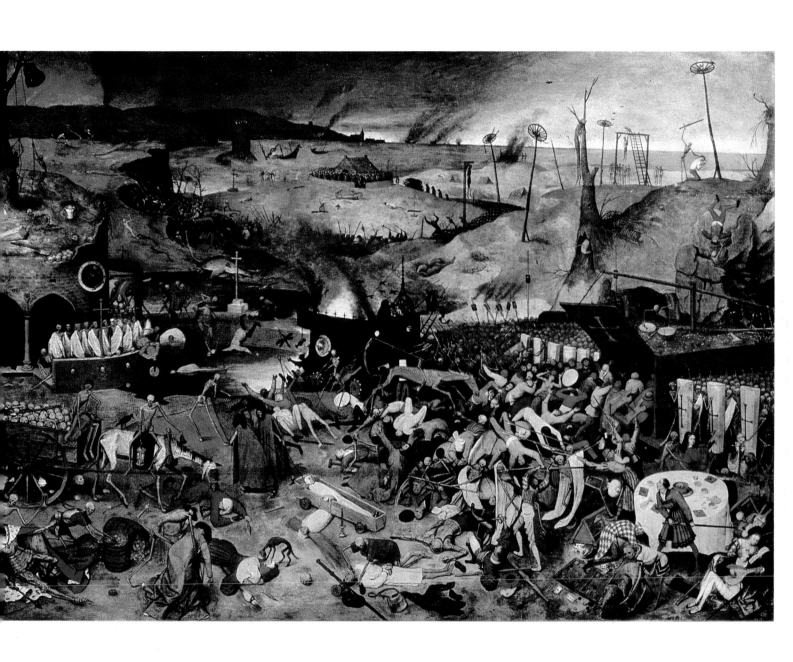

COLORPLATE 12

THE SUICIDE OF SAUL

Signed and dated 1562
Panel, 13¼ × 21⅝"
Kunsthistorisches Museum, Vienna

This small picture, dated (not very clearly but acceptably) 1562, bears an unusual added inscription by the artist which reads: "Saul. XXXI Capit." There is of course no Biblical book by the name of Saul, but the First Book of Samuel is in a sense the Book of Saul all the way from its ninth to its thirty-first chapter, and it is indeed the beginning of the thirty-first chapter of I Samuel which is depicted here; it is a rare subject, outside of Bible illustration, and Bruegel may have felt obliged to identify it (as nearly always, we do not know for whom). The Philistine army is defeating and annihilating the Israelite troops on Mount Gilboa; Saul's three sons have been slain; Saul himself, in armor and with the crown on his head, wounded, isolated, and threatened with immediate capture on a mountain plateau, has just killed himself by falling on his sword, and his armor-bearer is following him. The entire right foreground is filled to the brim with victorious Philistines and fleeing Israelites, rendered with an "impressionistic" brilliance which has its only sixteenth-century counterpart in Albrecht Altdorfer's *Battle of Issus* of 1529 in Munich (fig. 53); on the cliff in the center of the middle ground, a horrible slaughter (probably involving the sons of Saul) has taken place. All armor is of Bruegel's own time. In the background, "the men of Israel that were on the other side of the valley, and they that were on the other side Jordan" (31: 7) are seen forsaking the cities and fleeing.

In Dante's *Purgatory* (XII, 40–42), Saul—together with Nimrod (see *The Tower of Babel* of the following year; colorplate 14)—is among those represented (in a carving!) as an example of the sin of pride and punished for it:

Ah, Saul, how there by thine own sword pierced through,
 wast thou portrayed, dead on Gilboa, a spot
 which felt thereafter neither rain nor dew!

There is no doubt that Bruegel had the same intention as Dante's carver and his "patron," even though the Bible itself sees Saul's disastrous end as caused by his disobedience to God's voice (I Samuel 28:18).

The coloristic appearance of the panel is dominated by the green of the trees and the distance, the brown of the ground, and the gray of the armor. The armor-bearer is clad in a strong red, which is echoed in the red blood streaming from Saul's wound, two banners, blood, and some costumes in the middle ground, and a conflagration in the far distance.

Figure 53. Albrecht Altdorfer.
THE BATTLE OF ISSUS. 1529.
Panel, 62¼ × 47¼". *Alte Pinakothek, Munich*

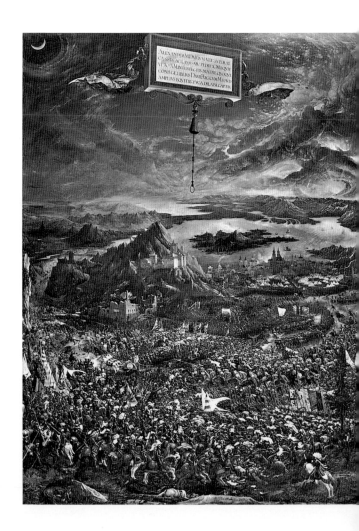

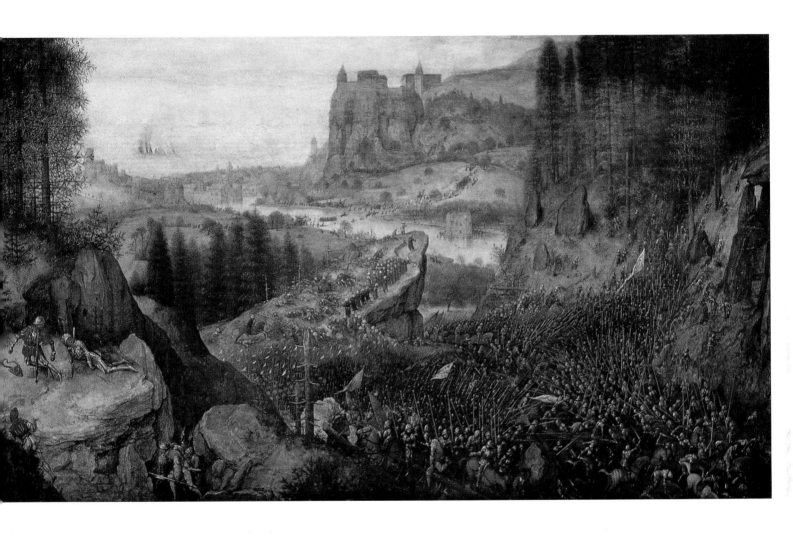

COLORPLATE 13

TWO MONKEYS

Signed and dated 1562
Panel, 7⅞ × 9″
Staatliche Museen, Berlin

In this unusually small picture, two dejected long-tailed monkeys (mangabeys) sit on the sill of a window which is so deep and surmounted by so low an arch, a *depressed* arch, that it immediately evokes the memory of a dungeon. They are chained to a central ring; the chains and the tails of the animals form a pattern of extraordinary beauty which is impeccably balanced against the highly diversified poses of the two bodies: one in front, quite near the left edge, with the head turned to the spectator, the other farther back and farther removed from the right edge, with the head seen in profile. Behind them is the harbor and city of Antwerp, clearly recognizable as such, spread in a bluish haze, enlivened by some reddish accents on the water. In the right foreground, rather prominently displayed, lie a few fragments of nutshells. The picture is immaculately preserved.

Monkeys have appealed to artists since time immemorial. Bruegel's are undoubtedly related to prints by Israel van Meckenem, which in turn are closely adapted from designs by Pisanello, but the animal at the left is even more intimately connected with that in Dürer's famous engraving of about 1500 (fig. 54). However, the expression of gloom is more marked than with either printmaker. These animals are gloomy because they are chained down. Why are they chained down? Most probably because they have given away their freedom for a hazelnut. To "go to court for the sake of a hazelnut" is exposed as folly by a Netherlandish proverb; a hazelnut is a trifle; the monkeys were trapped by their desire for such a trifle. And since we can assume that monkeys are here seen as analogies of men, the probability of Bruegel's having again remarked on the *human* folly of blindly selling one's liberty and true happiness for a material gain of an extremely dubious nature (probably even mere shells, no kernels) is great. The extraordinary smallness and intimacy of the picture even suggests a decidedly personal *raison d'être* for it. The picture is dated 1562; by Easter of the next year, Bruegel had departed from Antwerp, the city so lovingly represented in the background of the panel, and had become a resident of Brussels, according to Van Mander because of his future mother-in-law's insistence on that move. Was this picture painted when Bruegel was in the throes of a difficult decision involving the loss of his liberty? A gift to a friend who would have had to be left behind?

Figure 54. Albrecht Dürer.
MADONNA WITH THE MONKEY. C. 1500.
Engraving, 7½ × 4¾″

THE TOWER OF BABEL (I)

Signed and dated 1563
Panel, 44⅞×61″
Kunsthistorisches Museum, Vienna

This picture is almost twice as large as the undated Rotterdam version of the same Biblical subject (colorplate 15) and can be confidently assumed to be the earlier one. It is based on Genesis 11:1–9, in which the Lord confounds the people who began to build "a tower whose top may reach unto heaven," and it includes—as the other version does not—the scene of King Nimrod and his retinue appearing before the genuflecting crowd of workmen. This event is not mentioned in the Bible but was suggested in Flavius Josephus' *Antiquities of the Jews* (chapter 9); it was important to Bruegel as underlining the sin of the king's pride and overbearing which he intended to castigate here in the tradition of Dante's *Purgatory* (where the scene is represented in carving, XII, 34–36), and of recent literary treatments such as Sebastian Brant's *Ship of Fools*.

The rendering of the tower as a huge structure with ramps (though often *spiraling* ramps) became popular in fifteenth- and sixteenth-century book illumination; but the inspiration for other aspects of Bruegel's extraordinary architecture came from Rome, perhaps by way of early reminiscences and sketches, and of the series of prints made by Bruegel's main publisher, Hieronymus Cock, after the Colosseum. The oblong format in such a representation of the Tower of Babel occurs first in an early work by Jan van Scorel. To see *Roma in Roma sepolta* as a warning against human *hybris* was already an accepted *topos* in Bruegel's time. The tower is Babylonian in meaning, but a miracle of Roman engineering skill (as reimagined by a great artist) in substance; the commission given to Bruegel after 1565 by the City Council of Brussels, a series of paintings representing the digging of the Brussels-Antwerp Canal, suggests more than casual understanding of such matters on Bruegel's part. His most important forerunner in this respect was the painter of the miniature with the Babylonian

Tower in the *Grimani Breviary* in Venice (Simon Bening?—in any case a Netherlander before 1520), who populated the ramps and the environment of the tower with untold multitudes of workmen and building utensils, and showed Nimrod in a similarly commanding and slave-driving role. However, the tower of the *Grimani Breviary* has a square shape and looks much less Roman than does Bruegel's. A representation of this subject by Bruegel painted on ivory, thus presumably in miniature size, is mentioned in Giulio Clovio's inventory in 1577.

The details convey a clear idea of the immense meticulousness of Bruegel's rendering of the workmen's tasks. At the right is a huge crane, very similar to the one placed conspicuously above the harbor in the *Grimani Breviary*. The antlike laborers are busy loading it with huge stone slabs which they have received from below and will pass on to the higher ramp where others are prepared to receive them; one workman climbs a ladder toward that section, which is being transformed from rock into structured architecture by a host of other people. On the left, part of the facade is already being completed in part; a woman enters one of the gates, a ladder sticks out of one of the upper windows, farther up another large crowd of laborers works on the roof—and so on *ad infinitum*. Whatever the reasonableness of these individual actions may be—and this point has not yet been fully investigated—one immediately senses the grotesque inadequacy of means and the folly of the entire enterprise. However industrious these "ants" may be, they are up against hopeless odds which are brilliantly demonstrated. Within the same level, completion of the last detail stands against bare beginnings, with intermediary stages in between, thus intimating a frantic race against inexorable time, while the upper part is still invaded by clouds.

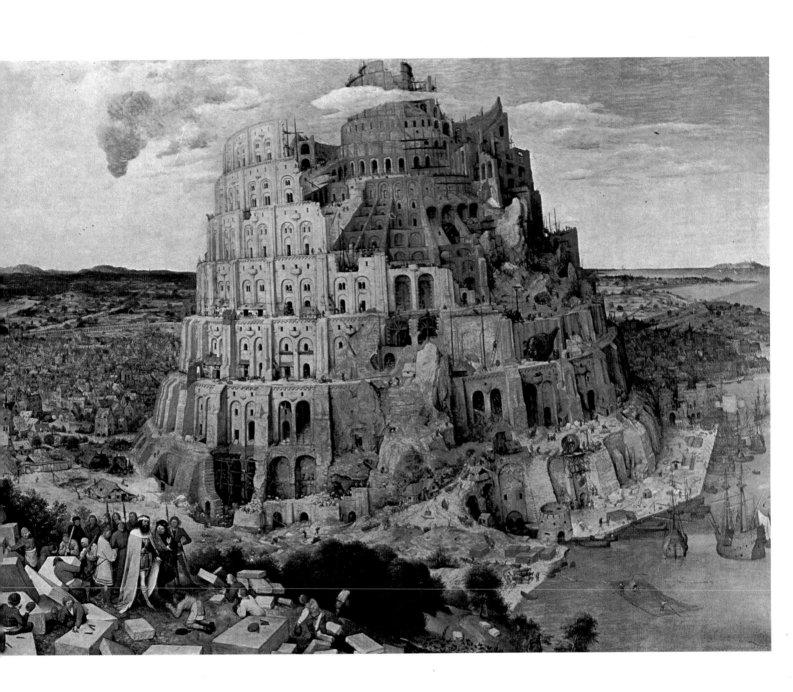

THE TOWER OF BABEL (II)

Datable c. 1564
Panel, 23⅝ × 29⅜"
Museum Boymans-van Beuningen, Rotterdam

This undated picture, much smaller than the Vienna version of 1563, was, with great probability, painted somewhat later, though perhaps only by a year or so. The tower, placed much closer to the picture plane, has taken on much greater severity and monumentality. The colors are darker. The Nimrod episode has been abandoned as detracting from the main point of the story rather than adding to it: the sin of pride speaks more eloquently through the insane project itself than through the cruel commands of the king to his subjects. The idea of transforming a rock into the tower has been dropped; the enterprise thus takes on an additional element of *hybris*. True, the structure is in a more advanced stage, but success is no nearer; while the antlike crowds on the lower ramps are no longer involved in construction, such work is still frantically pursued in the upper reaches and made to look even more futile by the display of architectural complexity in the inner recesses, the ominous red color, and the more threatening clouds. The handling of the landscape at the left and the harbor at the right is less miniature-like and more magisterial than in the version of 1563; and this is by no means the automatic result of smaller size. The host of imitations of Bruegel's treatment of this subject usually take *this* picture as their point of departure; they begin as early as 1568 (Lucas van Valckenborgh; fig. 55)—but they invariably miss the grandeur of their model by pushing the tower back into space and treating it like an *objet d'art*.

Figure 55. Lucas van Valckenborgh.
THE TOWER OF BABEL. 1568.
Panel, 8¼ × 11⅜". *Alte Pinakothek, Munich*

COLORPLATE 16

THE PROCESSION TO CALVARY

Signed and dated 1564
Panel, 48¾×66⅞"
Kunsthistorisches Museum, Vienna

This is the largest picture Bruegel ever painted and one of the richest, not only in detail. In a sense it can be said to contain a full account of what Bruegel considered most wrong in the relationship between man and God, namely man's insensitivity to goodness and holiness, his refusal to follow Christ. Its immaculate preservation and consequent brilliance of color make it a particularly important testimony to Bruegel's greatness as a painter.

The concept of combining the depiction of the procession of Christ to the calvary with a prominent landscape in such a way as to give approximately equal importance to both elements was very familiar in Northern painting before Bruegel. It occurs with Pieter Aertsen (1552, fig. 56), Cornelis Massys, the

so-called Brunswick Monogrammist, and Herri met de Bles (fig. 57). The Princeton panel by the latter artist comes as close to Bruegel as one can expect; as in some other cases, its landscape is a relatively close anticipation of Bruegel's, and the long procession, moving parallel to the picture plane throughout the width of the picture, toward the place of execution in the far distance on one side, with Christ near the center, is also comparable; so are some details like the running boy in the foreground and, even more important, the extraordinary freshness and brilliance of its colors. And yet Bruegel's work is of vastly greater artistic and spiritual significance. The group of the holy relatives and friends of Christ, tucked away in the background in Aertsen's and

Figure 56. Pieter Aertsen.
PROCESSION TO CALVARY. 1552.
Panel, 30¼ × 45¾".
Formerly Staatliche Museen, Berlin

Figure 57. Herri met de Bles.
PROCESSION TO CALVARY. C. 1535.
Panel, 32¼ × 44⅞".
Princeton University Art Museum

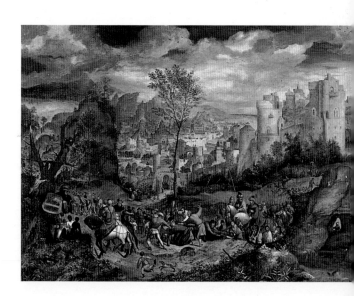

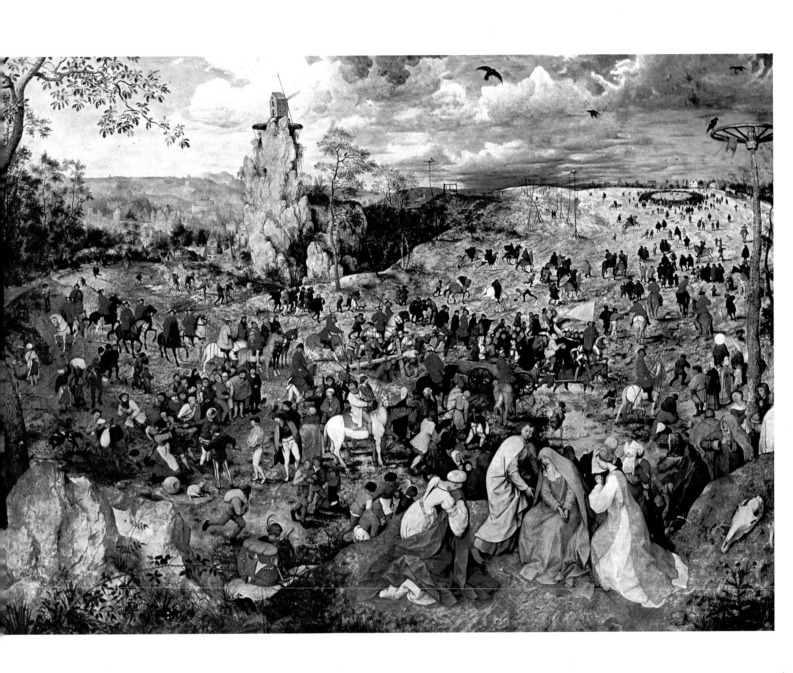

Bles' interpretations, had already been pulled to the front by Cornelis Massys (Musées Royaux des Beaux-Arts, Brussels), but given only moderate emphasis; Bruegel made of it one of his most moving and powerful visualizations of sorrow. The figure of Christ was pushed back—still in the center but difficult to discover at first sight—in order to increase the impact of the two other main (and interrelated) aspects of the story: the grief of his friends and the callousness of the average man. It is true that the slighting of the main theme is also a common formal principle of Mannerism, but it is significant that Bruegel employed it, not as a fashionable device, but for a highly expressive purpose. The less we see of Christ—whose fate is clearly enough reflected in the sorrow of his friends—the more room there is for a display of the indifference of the common man witnessing the greatest tragedy of Christianity without realizing what it means to him and to mankind as a whole. It was a day of excitement because of a triple execution, otherwise a day like many others; people came to satisfy their curiosity or just to loiter.

Special emphasis is given to the story of Simon of Cyrene in the left middle ground. In the presence of a half-amused, half-embarrassed crowd, he is about to be forced by some soldiers to join the exhausted Christ and help Him carry the cross; but his "pious" wife—who wears a rosary with a cross!—is fighting with might and main to hold him back, and the irony of the official executioners of Christ showing a more human attitude toward Him than "mankind" is brought home with tremendous power. This episode, missing in Bles' work (fig. 57), was prefigured in Aertsen's picture of 1552 (fig. 56), where it was told with vigor and in a form which seems to have impressed Bruegel, but characteristically without his strong emphasis on the stupidly watching crowd which epitomizes the lack of human comprehension and sensitivity almost more poignantly than the woman's action. And so it goes throughout the picture: an almost kermis-like frivolity is joined by a complete lack of understanding of the unfolding supreme tragedy; the "red thread" of the equally uncomprehending soldiers on horseback lays out the factual road of it; the victim is almost buried in that mass of human inadequacy. Nobody in that crowd seems to even notice the great group of the mourners, whose ideal-

ized garb indeed characterizes them as not being of the same world as they.

A preparatory study for one of the spectators near the execution wheel on the right has survived in a drawing now at Rotterdam (fig. 58; the right figure); it is one of only two or three such cases known to us.

Figure 58. Bruegel. TWO SPECTATORS. 1564.
Drawing, 6 × 3¾".
Museum Boymans-van Beuningen, Rotterdam

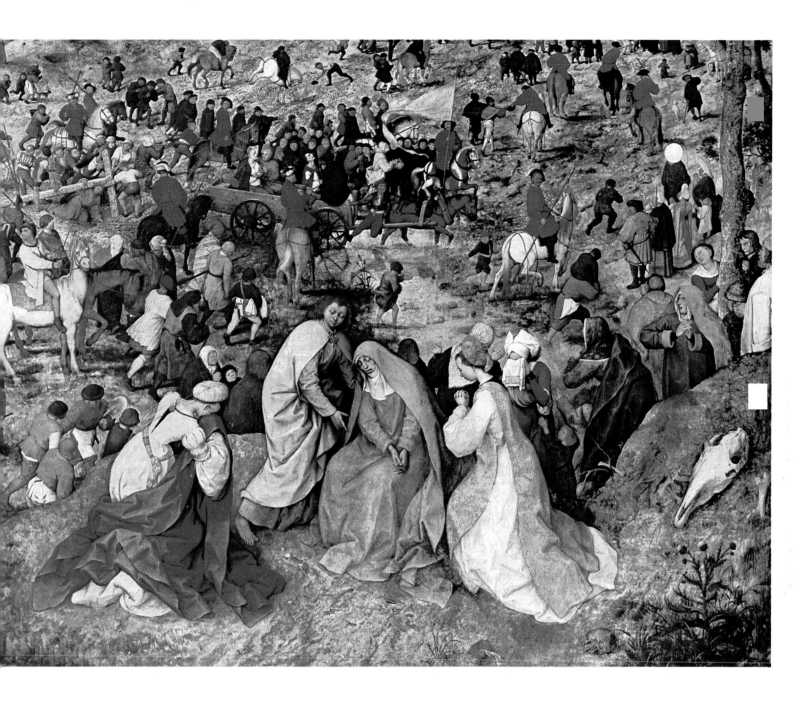

COLORPLATE 17

THE PROCESSION TO
CALVARY

(detail)

COLORPLATE 18

THE ADORATION OF
THE KINGS

Signed and dated 1564
Panel, 43¾×32⅞″
The National Gallery, London

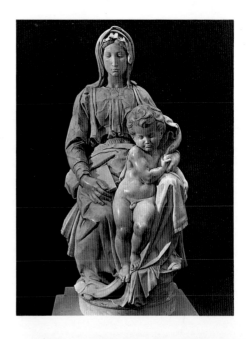

Figure 59.
Michelangelo.
BRUGES MADONN[...]
1503–4.
Marble, height 5[...]
*Church of
Onze Lieve Vrouw[...]
Bruges*

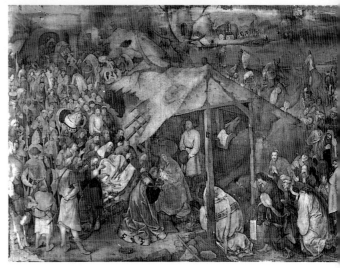

Figure 60. Bruegel.
THE ADORATION OF THE KINGS. C. 1556–58.
Canvas, 45 ½ × 64″.
Musées Royaux des Beaux-Arts, Brussels

This large picture, the first among Bruegel's large-figure compositions, is exceptional for two reasons: first, it is—but for the *grisaille* of the *Resurrection* (see fig. 33)—his only painting in upright format; and second, it is—except for the *grisaille* of *The Adulteress* (fig. 9)—the only painting of his that shows a very strong Italian influence both in structure and in details. The proportions of the panel are those of a typical altarpiece, although it is difficult to imagine that it was intended as such. Its structure evokes memories of Italian representations of the same subject; the almost Masaccesque figure of the Moor and the kneeling and bending bodies of the two other kings, more reminiscent of the late Quattrocento, point in the same direction; the Christ Child betrays, at least in the upper part of His body, the influence of Michelangelo's *Bruges Madonna* from the turn of the century (fig. 59). The contrast to the still distinctly Boschlike, very early, poorly preserved canvas with the same subject in Brussels (fig. 60) could hardly be greater. Yet, nobody could possibly mistake the London panel for an Italian work, even apart from the physiognomies of the soldiers and other bystanders, which exhibit the same uncomprehending, though not necessarily unfriendly, stares which we find again and again in the faces of witnesses tò sacred stories in Bruegel's paintings. If one searches for ancestors of these characteristics one would have to turn to Hugo van der Goes rather than to any Italian sources; but even there one would find no antecedent for the weather-beaten faces of the two white kings, and for the haunting expression on the face of the Moor which hovers between shock and the dawn of a radiant smile. An iconographic rarity that Bruegel has strongly emphasized is the tattletale whispered into Joseph's ear by a malicious young fellow. The question of Joseph's doubt in Mary's purity is an old one and has never completely ceased to occupy writers and painters,

who sometimes represented Mary's own defense against Joseph's doubt or his apologies to her; but Bruegel's straightforward gossip, to whom Joseph seems to react with equanimity rather than shock, remains very exceptional. It is characteristic of Bruegel that even in this hallowed subject he felt obliged to introduce a reference to human sinfulness.

The picture is an outstanding example of Bruegel's superb skill as a composer in color: the interweaving and balancing of partly strong, partly subdued reds, pink, green, black, dun, and chamois are handled with impeccable taste, and blue is reserved for the central figure of Mary, with only a few minor echoes admitted elsewhere.

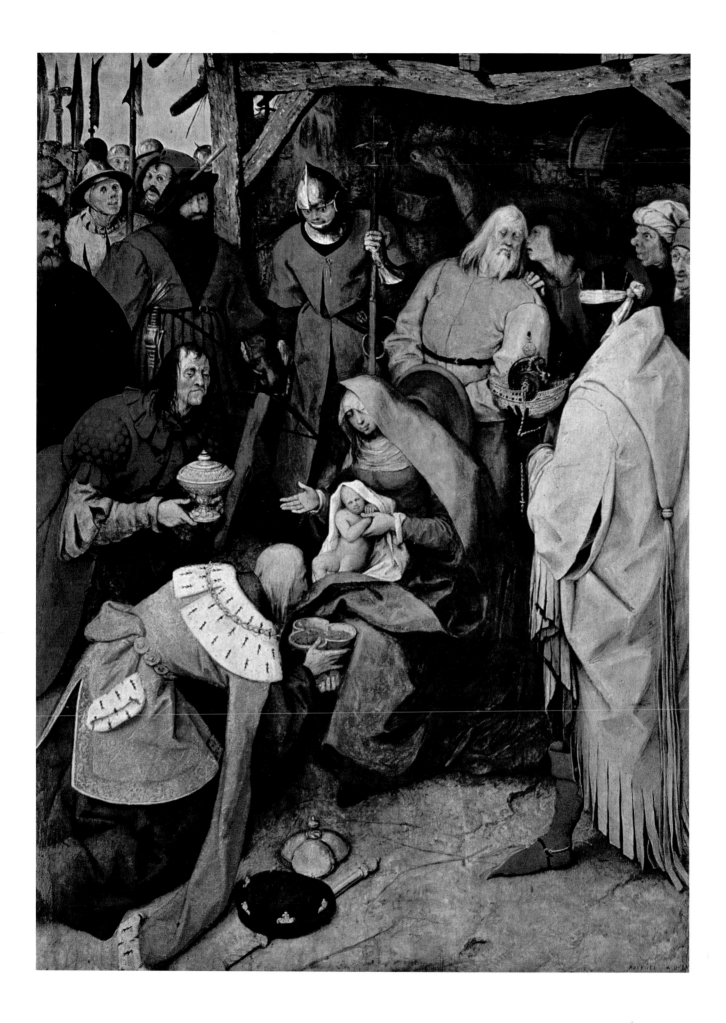

COLORPLATE 19

THE SLAUGHTER OF THE INNOCENTS

c. 1564(?)

Panel, 45⅝×63″

Kunsthistorisches Museum, Vienna

There exist two versions of this composition, neither of them signed or dated: one in Vienna, the other in Hampton Court (fig. 61). A decision as to which of them has the greater claim to being autograph is made particularly difficult by the fact that both have suffered considerably. In its well-preserved parts, the Hampton Court version looks superior, but it is the Vienna picture that represents Bruegel's original intentions more clearly, particularly in the depiction of the slaughtered children, bowdlerized in the other version.

In spite of constantly renewed attempts to see in this picture an allusion to the terror regime of the Duke of Alba, no such connection can be made plausible. Its date is most probably earlier, and certainly not later, than that of the two other winter landscapes with Biblical scenes (1566 and 1567), and there were

no Spanish troops on Flemish soil between 1560 and 1567. It is obvious that the Biblical story is here, as elsewhere, seen in terms of Flemish everyday life, but that does not encourage the assumption of a specific political meaning. The imposition of taxes on Flemish villages and its enforcement by gendarmes was a common enough experience; naturally it was imperial authority (see the double eagle on the shirt of the apologetic-looking herald in the right middle ground) that was in charge. Just as *The Census at Bethlehem* or *The Adoration of the Kings in the Snow* takes place in a Flemish village of Bruegel's time, so does *The Slaughter of the Innocents;* but Bruegel did not slight the grim aspects of the Biblical tale (this was reserved for those later hands that overpainted the dead children in the Hampton Court version). The wholesale murder ordered by Herod is depicted as a winter scene because it happened just after the birth of Christ. The snowfall has blanketed the peaceful village which has suddenly become a place of random slaying, desperate but fruitless pleas, and forlorn wails over torn little bodies. Houses are broken into and searched for more victims as the phalanx of mailed horsemen seals off the middle ground with terrible finality. Beyond, there are only silenced houses, bare trees, and a leaden winter sky.

Figure 61. Bruegel.
THE SLAUGHTER
OF THE INNOCENTS.
c. 1564(?). Panel, 43 × 61″.
*Hampton Court. Reproduced by
gracious permission of
Her Majesty the Queen*

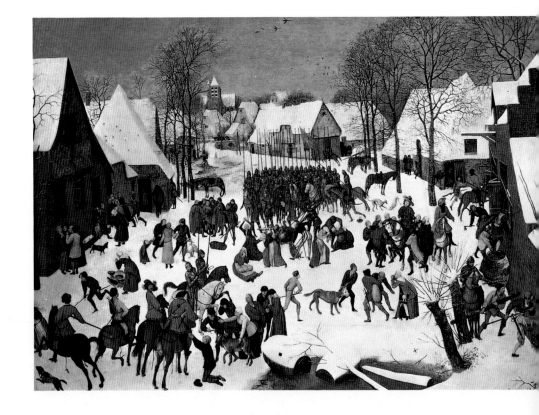

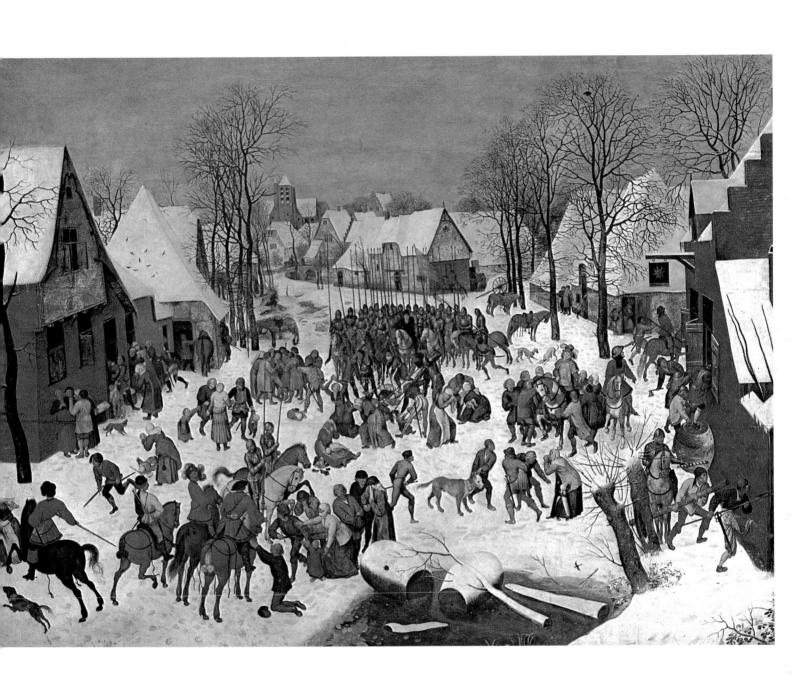

THE HUNTERS IN
THE SNOW

Signed and dated 1565
Panel, 46×63¾″
Kunsthistorisches Museum, Vienna

Two of the few unquestionable facts about the highly complicated subject of Bruegel's series of the "Months" are that we still have five paintings belonging to it (three in Vienna, one in New York, one in Prague, the first four dated 1565), and that these were together in the house of a certain Niclaes Jonghelinck in Antwerp as early as February, 1566. From this one can gather with the greatest probability that they were painted for Jonghelinck's palatial home as part of a large decorative scheme; but of the nature of this scheme nothing certain is known. Nevertheless it is becoming more and more probable that twelve such paintings originally existed, rather than—as has ingeniously been suggested—only six, each representing two months (a series of the "seasons" is of course out of the question). In 1566, Jonghelinck owned altogether "sixteen paintings by Bruegel, among them *The Tower of Babel,* a *Procession to Calvary,* the *Twelve Months.*" It is highly improbable that the titles of eight pictures—rather than only two—would have been omitted from the inventory record; the objection that it is equally improbable that no trace has remained of the others, either in originals or copies, can be countered with the argument that the seven missing panels could have perished in a fire or been discarded for some such reason as their being unfinished, and that no exact copies of the extant ones (except of *The Harvesters*) seem to have been preserved either. The present paintings can confidently be identified with the five specifically enumerated in 1657 in the collection of Archduke Leopold Wilhelm, the main founder of the Vienna Museum (here they are inappropriately called the "Seasons"); on the other hand, David Teniers, in his catalogue of the same collection written in 1660, speaks of "six pictures representing the variety (*diversité*) of the Twelve Months by the

old Bruegel," an interpretation which does indicate the presence of a problem, and which may have been encouraged by the fact that series specifically thus described must have existed in a different Hapsburg collection in 1595 (also described as "Six Seasons!"), and in the late seventeenth century. Altogether, the problem of identification is so complicated, regardless of whether one believes in one or two months in each panel, that we shall cling to the *descriptive* titles for each of them.

In this series Bruegel is still linked to a medieval tradition which considers the life of man in terms of his dependence upon the cycle of the year. The winter scene of the series most probably represents January, as its iconography agrees most fully with that of this month in representations of the *Labors of the Months* in the calendars of illuminated books of the fifteenth and sixteenth centuries, to which Bruegel was indebted in many other ways as well. However, it is characteristic that while he retained motifs from these sources, he used them freely and occasionally altered them considerably.

It is true that the killing and bleeding of a pig was a traditional feature of calendar illustrations for *December,* and Bruegel adapted it for December in *The Census at Bethlehem* a year later; in the present panel he chose the singeing of the pig as anticipated in the *December* of the so-called *Heures de Hennessy,* illuminated by Simon Bening about forty years before Bruegel (fig. 62). The strongest argument for this picture representing January rather than December is its *main* motif, the return from the hunt, although here Bruegel differed from the current usage by replacing the rabbit hunt with fox hunters (while the inn is inscribed as "Under the Stag" and has a picture of Saint Eustace on its signboard). In the distance, before soaring

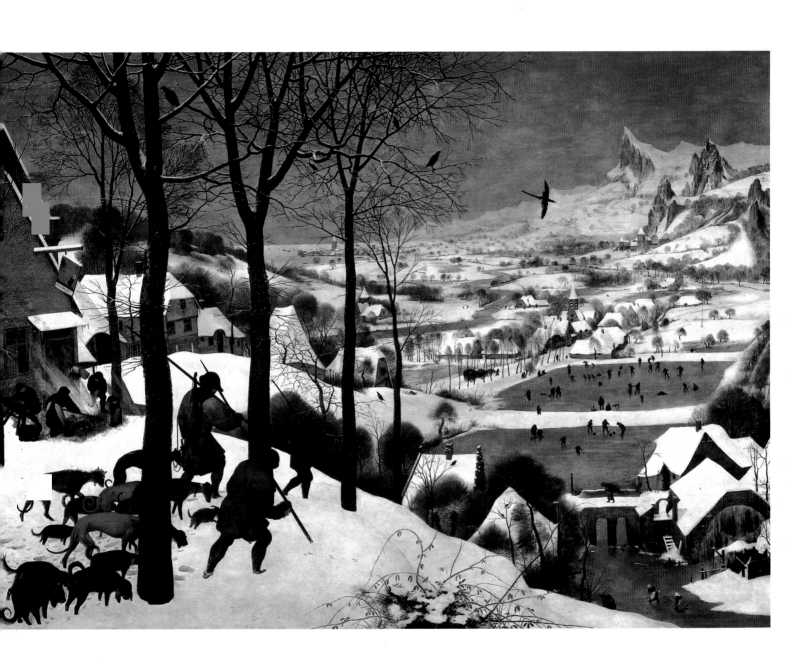

Alpine summits reminiscent of the mountain drawings Bruegel brought back from his southern journey and of the series of engravings published about 1560 (figs. 29, 41), a wintry microcosm is displayed in inexhaustible detail and with inexhaustible ingenuity of accommodation: ponds with skaters and hockey players, figures curling and spinning tops, a village with a church, firemen putting out a chimney fire, a water mill, people shooting birds, a distant city. However, the decisive feature of this panel is its monumental main structure. The uninterrupted diagonal procession of the hunters and their dogs, accented by the stately trees, penetrates into middle ground and distance, and yet, together with the opposing diagonal formed by the sloping contour of the foreground hill and the mediating diagonal of the background mountain, reaffirms the frontal plane of the picture and establishes that perfect balance and two-dimensional rhythmic order without which even the greatest illusion of depth and the most wonderful display of details would create nothing but confusion. Nevertheless, the powerful diagonal toward the right which is so characteristic of this picture—and only of this one in the series—strongly suggests that it was the first item of the decoration of a room in Jonghelinck's house; and this also corroborates its interpretation as January.

The picture seems to be less well preserved than the other panels of the series and Bruegel's other winter scenes, but the reduction to a few subdued hues and the wintry crispness of design still provide a telling contrast to the wealth of brilliant colors in the other pieces, particularly *The Harvesters*. A preparatory sketch for one of the hunters has survived in the University Library in Uppsala (fig. 63); besides the drawing for the *Calvary* (fig. 58) and perhaps one for the *Carnival and Lent* (colorplate 3), it is the only such document preserved for us.

Figure 62. Simon Bening.
DECEMBER, from the *Heures de Hennessy*.
c. 1520–30.
Bibliothèque Royale Albert I, Brussels

Figure 63. Bruegel.
WALKING HUNTER. 1565.
Drawing, 6⅛ × 3⅞".
University Library, Uppsala, Sweden

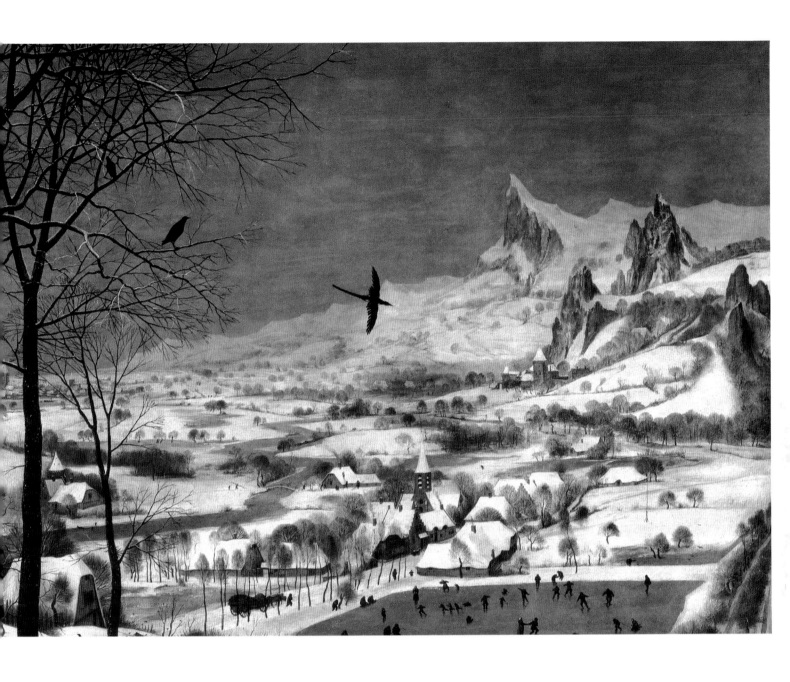

COLORPLATE 21

THE HUNTERS IN
THE SNOW

(detail)

COLORPLATE 22

THE GLOOMY DAY

Signed and dated 1565
Panel, 46½ × 64⅛"
Kunsthistorisches Museum, Vienna

The correct identification of the subject of this panel is greatly facilitated by the two main actions on the right which are marked by the most vivid colors on the entire surface. The man in blue and red is busy pollarding a willow tree, while the one in yellow and brown is tying cut branches in a bundle; the man eating a waffle, the woman near him, and the child with the lantern and paper crown led by her, are unmistakable Carnival revelers. Carnival occurs in February, and the lopping of trees is likewise connected with February in some calendar illustrations; where it goes with March instead, as in the *Heures de Hennessy* (fig. 64), February is often typified by related work in the vineyards. Minor activities are concentrated in the village on the left: before the inn (named "Under the Star"), a woman and a child take a man to the door by which a fiddler entices clients to enter;

another peasant has already had more than his fill of drinks. A leaking roof is being repaired; a woman is working in a flower bed; a man seems to be winnowing grain. Across a sea of roofs way down and back, there opens up a vast panorama of water, mountains, and sky; in the bay the waves rise high, and ships are in jeopardy; farther back on the right, other ships are imperiled near the shore where people come to the rescue; the sky is still black. Coloristically, the February gloom is all-pervasive with the exception of the gay hues which signify working and reveling, and of the brilliant white of the attic on the right, which is counterbalanced by the snow-covered summits in the left background. The greatest find of this panel is the wonderful filigree work of the central trees seen against houses, a spit of land, water, mountains, and clouds.

Figure 64. Simon Bening.
MARCH,
from the *Heures de Hennessy.*
c. 1520–30.
Bibliothèque Royale Albert I,
Brussels

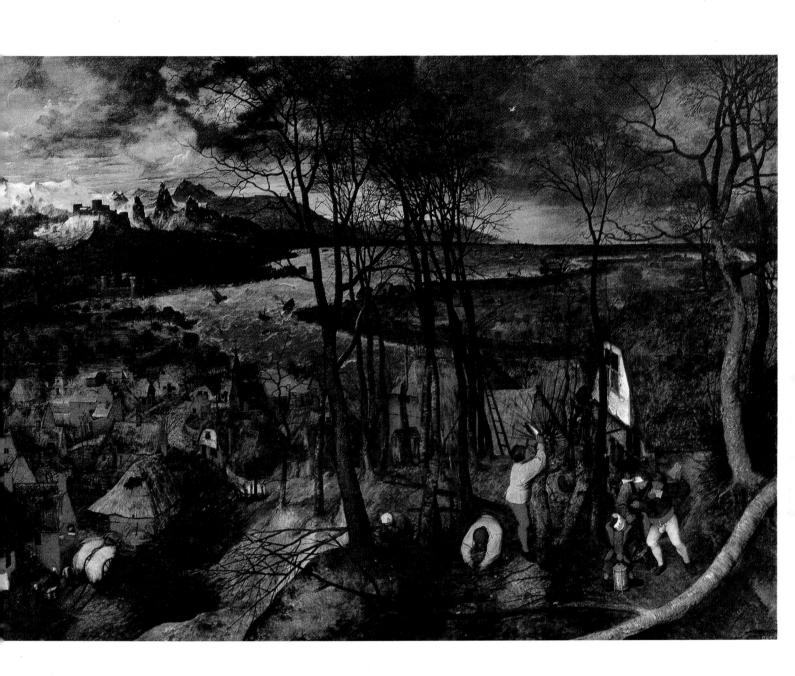

HAYMAKING

Datable 1565
Panel, 46×63⅜"
National Gallery, Prague
From the Collection Prince Lobkowitz

Figure 65. Simon Bening.
JULY, from the *Heures de Hennessy*. c. 1520–30.
Bibliothèque Royale Albert I, Brussels

Figure 66. Pieter Paul Rubens.
RETURN FROM THE FIELDS. c. 1635.
Panel, 47⅝ × 76⅜".
Palazzo Pitti, Florence

This is the only picture of the "Months" series which is not signed and dated, but there cannot be any doubt that it formed part of the Vienna–New York group as it agrees exactly with it in size, style, and interpretation, and was already listed together with it as a series of five panels in 1657. Its main subject, *Haymaking*, points to the Netherlandish word for July (*Hooimaand*, Hay Moon) as the correct title; in Netherlandish calendar illuminations, too, particularly in the *Heures de Hennessy* (fig. 65), haymaking appears (twice) as the July labor.

Coloristically, this is the gayest and perhaps the most splendid of the series. In contrast to the all-pervasive yellowness of the New York *Harvesters*, it is a fresh green in many shades and an enchanting blue which dominate the gamut, blending with judicious touches of a warm—but not hot—red. There is here no attempt to penetrate into the depth of the picture; the area is seen in terms of quiet parallel strata, for which the road in front sets the pace with its leisurely sequence of the man sharpening his scythe, the three women with rakes, the basket bearers, and the peasant woman on horseback—a sequence marking rest, movement to the left, and movement to the right, in a lively but unhurried way. Two of the three women carrying rakes are exceptionally attractive compared with Bruegel's usual types which tend to bring out the coarse elements in humankind, and the entire group is of a charming variety, yet of a wonderful unity to which the rhythm of their lively gait contributes significantly; no wonder that Rubens fell under their spell and freely adapted them when it was his turn to represent the enchantments of a summer landscape (fig. 66). Here, for once, Bruegel felt human beings to be in *complete* harmony with nature; when they idle, and sometimes even while they are doing their work, various degrees of ugliness remain, but here they are free of both idleness and work load, with a good conscience, happy, and radiant.

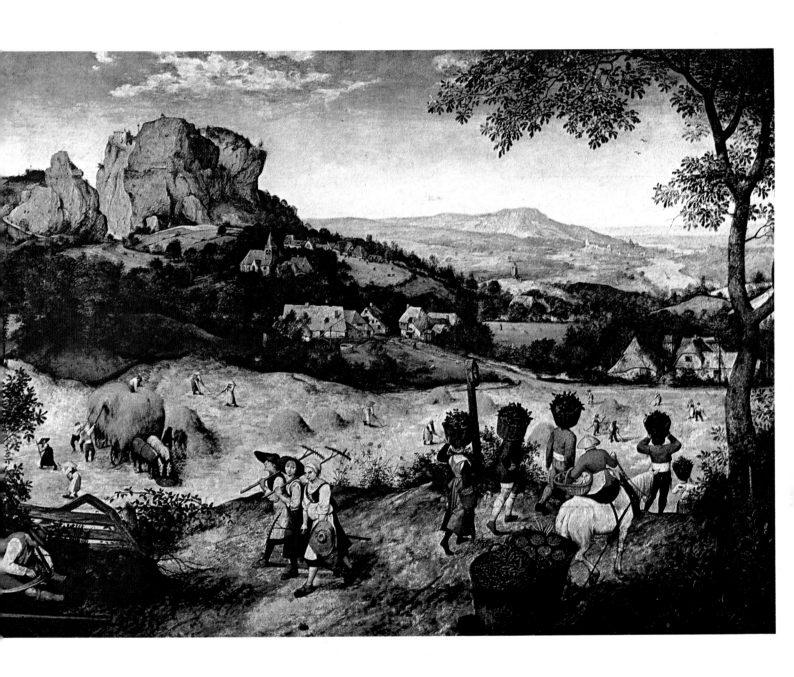

THE HARVESTERS

Signed and dated 1565
Panel, 46½×63¼″
The Metropolitan Museum of Art,
New York City
Rogers Fund, 1919

The Harvesters is almost certain to stand for August, rather than July, although the latter is occasionally illustrated by a wheat harvest in book illumination. The Netherlanders call August the Harvest Moon (*Oogstmaand,* cf. the Hay Moon for July); and since haymaking is the decisive activity in the other summer picture and wheat harvesting is the decisive activity here, it is logical to assume that the Netherlandish nomenclature can be applied to both. In the *Heures de Hennessy* (see under July), the iconography of both miniatures illustrating the labors of August is given over to the wheat harvest. Certainly, if the represented activities did not define this as the epitome of late summer, the color of the picture would. The great central mass of wheat, which dominates its scattered tributaries, dwarfs nearly everything with its unimpaired yellowness. Only the one great pear tree toward which the group of eating, drinking, and resting laborers is magnetically drawn is strong enough to counterbalance the vast reaches of wheat which on the left almost seem to swallow up the workmen; it forms the backbone of the entire composition. Where there is plenty of food, drink, and sleep, Bruegel characteristically indulges his habit of making man appear as a slave to them: the faces of the eating and drinking peasants have dumb, somewhat animal-like features, their poses are awkward, the posture of the sleeper anticipates the total abandon of the idlers in *The Land of Cockaigne* (colorplate 30).

As in the *Haymaking* panel, the artist has placed little emphasis on diagonals reaching toward depth or working within the background area. Across the yellow sea at the left, a quiet countryside with meadows and other wheatfields spreads in more or less parallel strata; on the village green, peasants disport themselves; a church tower rises above a town situated on the shore; farther back the lilac haze blends with the sky. On the right side, the ground rises toward a wooded hill and a church with a blue roof: a miracle of pictorial wealth and subtlety which anticipates not only the landscape of the *Magpie* of 1568 (colorplate 38), but also some of the congenial landscape backgrounds of Rubens.

In a drawing of 1568 (fig. 32) Bruegel returned to the subject of *Summer* as defined by the wheat harvest; but this composition is dominated by man, not by landscape. Its right side spells labor, its left side, rest, each summed up by one towering individual—a faceless person (there are practically no faces in the entire drawing) indicating the *typification* of the activity here represented. The main ancestor—besides the *Laocoön*—of the drinking man, not the working man, is Michelangelo; but while in the latter's world the torsion of a human body evokes the image of a prison of the divine soul, the torsion of Bruegel's figure evokes the image of a human urge, induced by hard work, elevated to an almost supernatural grandeur.

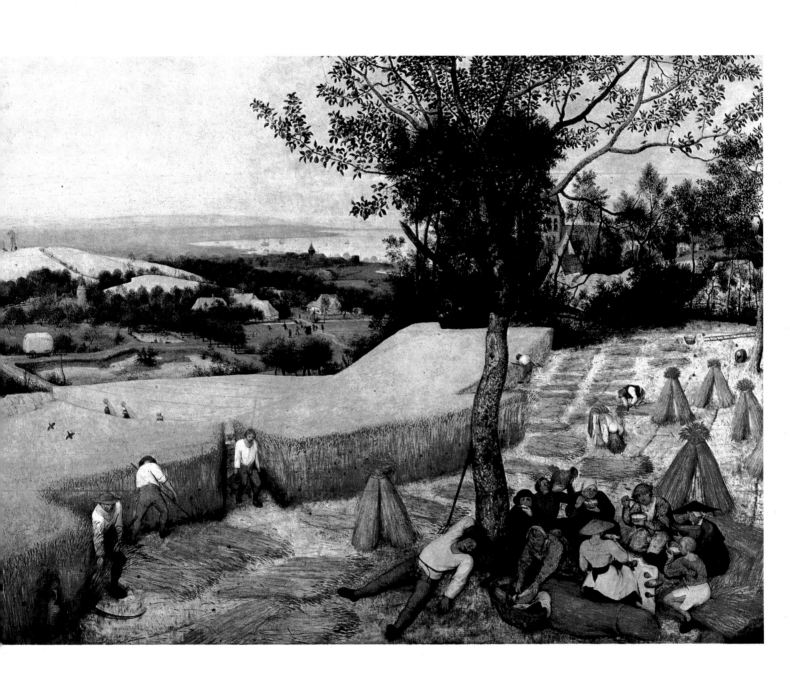

COLORPLATE 25

THE RETURN OF
THE HERD

Signed and dated 1565
Panel, 46×62⅝"
Kunsthistorisches Museum, Vienna

The main motif of *The Return of the Herd* does not seem to occur prior to Bruegel as the unmistakable property of a single month. The bare trees of the Vienna picture seem to plead for November, and a painting by Maerten van Valckenborgh (fig. 67), which is otherwise indebted to Bruegel as well and is certain to have been intended as a representation of November, does show the return of the herds in the middle ground. On the other hand, in Bruegel's painting, the relatively conspicuous vintage scene (right middle ground, this side of the river) goes better with October; so does the trapping of birds (center, behind the foreground procession); people seem to be gathering nuts on the other bank of the river (left of the village). It is probably idle to speculate on the position of each of the preserved paintings in the decoration (frieze?) in Jonghelinck's house, with the notable exception of the initiating *Hunters in the Snow*; nevertheless, one senses in *The Return of the Herd* a strong orientation to the left, and this would suggest a place at the end of a wall (opposite the winter picture?), with one or two paintings to follow on a narrow wall.

 Certainly the procession of the herd and the river lead in parallel diagonals from right to left, although there is—as in the winter scene—enough counteraction to guarantee a large degree of self-sufficiency. The peasant on the left and the two cows joining in his direction from left to right fulfil this task brilliantly, and so does the bend of the river to the right in the distance, strongly supported by the mountainous left bank. The trek of the compact majority of the cattle directly into the picture, bordered by slender

trees on their left and right, magnificently suggests the climax of this return; the horseman and the two companions near him on foot bring up the rear as they emerge from the right, and are joined by the solitary tree and the third man on foot. Most of the cattle are golden brown and gray-brown, blending to a degree with the fields and the trees; the white bull in the center of the foreground stands out, yet epitomizes the herd, its strength, its direction, its homecoming.

Figure 67. Maerten van Valckenborgh.
NOVEMBER. C. 1590–95.
Canvas, 33⅞ × 48⅜".
Kunsthistorisches Museum, Vienna

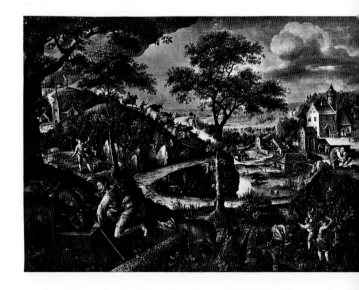

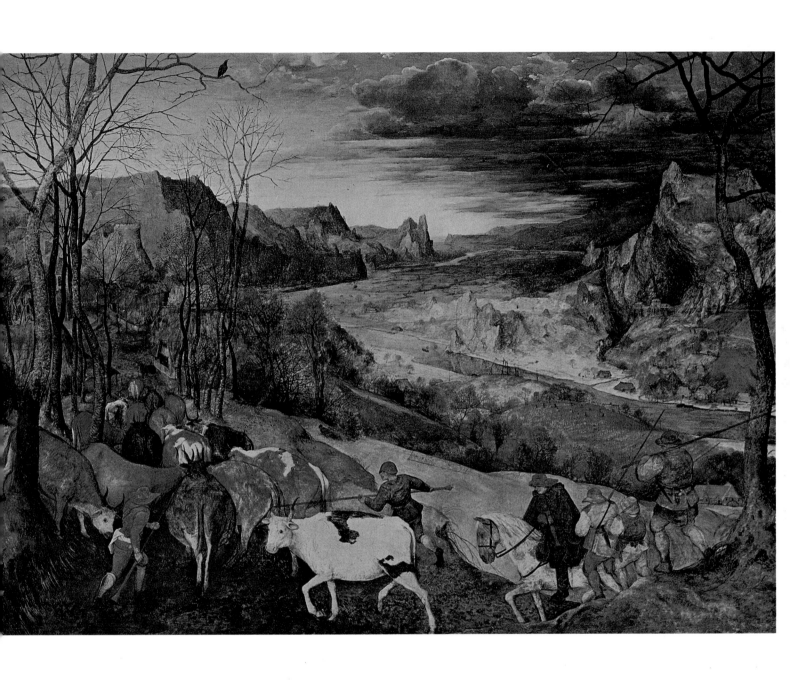

COLORPLATE 26

WINTER LANDSCAPE WITH A BIRD TRAP

Signed and dated 1565
Panel, 15 × 22″
Collection Dr. F. Delporte, Brussels

This small panel forms a telling contrast and a significant supplement to the large and powerful series of "Months" of the same year. The picture must have enjoyed an especially high reputation which one can gather from the fact that a host of replicas exist, several of them signed by Bruegel's elder son, Pieter Brueghel the Younger, and at least one other panel which vies with the present version for the father's own authorship, and bears not only his signature but strangely also the date 1564, one year prior to the date of the Delporte version. With *The Hunters in the Snow* in Vienna (colorplate 20) this picture shares the wintry atmosphere with its great preponderance of black-white-gray-brown and a few red nuances; but their compositions differ noticeably. In the Vienna panel, the large figures of the hunters set the pace for the entire sequence of structural "events"; they define it iconographically and compositionally. In the small panel, no such pacemakers are observable, and at

first glance one is tempted to interpret it as a landscape pure and simple; indeed, its great popularity during the following generation is probably due to that very fact. Nonetheless, it is very doubtful that this is, as it were, a Jacob Grimmer or Hendrick Avercamp *avant la lettre*. The bird trap, which is quite prominently set off from its snowy surroundings in the right foreground, surely had a similarly prominent *meaning* for Bruegel's contemporaries, even if that meaning escapes us now; and the huge crow in the upper right corner is far too obvious to be "just a bird": it stands out like a monumental warning to the birds that busy themselves all too near the trap. The peaceful environment, with smug houses and insouciant skaters, is misleading: danger lurks everywhere and warnings must be heeded; and this also applies to the men who in the center of the foreground are painted—surely not accidentally—in seemingly equal size with the two birds sitting on a branch.

It is often assumed that Bruegel's drawing of 1558 or 1559 which represents *Skating Outside Saint George's Gate* at Antwerp (fig. 68) and was engraved by Pieter van der Heyden, is simply a scene of everyday life. But even here such an interpretation is doubtful since the engraving bears a caption in which the subject is called: "The Slipperiness of Human Life"; and some of the actions and attitudes make this meaning indeed plausible.

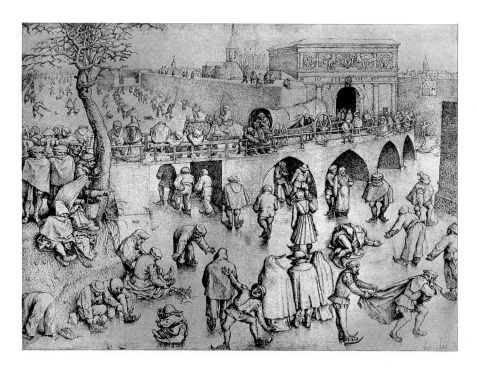

Figure 68. Bruegel.
SKATING OUTSIDE SAINT GEORGE'S GATE.
1558 or 1559.
Drawing, 8⅜ × 11¾″.
Private collection

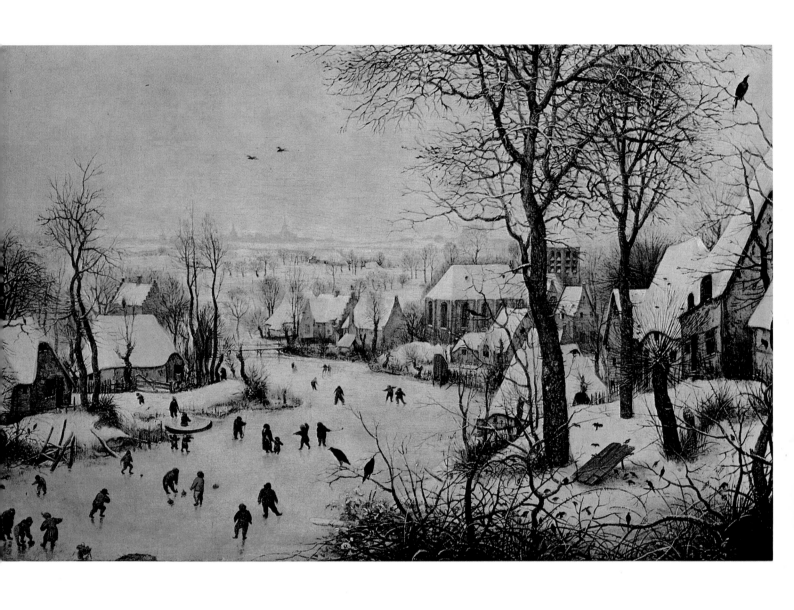

COLORPLATE 27

THE CENSUS AT BETHLEHEM

Signed and dated 1566
Panel, 45⅝×64¾"
Musées Royaux des Beaux-Arts, Brussels

This large picture—of almost the same size as the series of the "Months"—is based on Luke 2:1–5. As was to be expected, Bethlehem is seen as a Flemish village at wintertime. A little to the right of the center, one sees Joseph and Mary, seated "great with child" on the ass, already accompanied by the ox. They are about to join the crowd that assembles in front of the inn (at the left) and is dumbly submitting to the census and concomitant taxation; one of them is seen paying his obolus to the official, while a scribe is putting it down in writing. This rarely represented scene (the mere arrival of Joseph and Mary is a bit more frequent) has been expanded to include a large show of everyday life in a Flemish village of 1566. The inn itself, in which the census takes place, and its surroundings are typical of this: the wreath, the pitcher on the wall, the man opening the attic window, the people thronging into the warm interior, the

catching and slaughtering of pigs in anticipation of hungry travelers, the arrival of large barrels, the busily pecking chickens. And there is much more of this elsewhere: people warming themselves at a large fire in front of a stately dwelling, a drink being served near a hollow tree used as an auxiliary inn, children fighting and throwing snowballs, construction of a wooden shelter, wagonloads arriving, children sledding and spinning tops on a frozen pond in the right foreground, traffic across a frozen river toward and from another part of the village (with the church) in the left distance. A very red winter sun is rising above that section, partly hidden by the large bare tree that stands in front of the inn. With superb skill Bruegel has indicated that in a sense Joseph and Mary are only two of this huge number, just as the Biblical text suggests; yet they are also modestly singled out by their place within this large group, by Mary's blue mantle, and by the familiar ensemble of ox and ass. The somewhat enigmatic, dilapidated little hut in the right middle ground is distinguished by a cross over its gable; it is most probably the hut in which Mary was to bear the Child a few days later, and it does not look too different from the building before which the Magi kneel in the snow of the picture of 1567 (colorplate 32). The architecture of the background contains reminiscences of the towers and gates of the city of Amsterdam which Bruegel seems to have visited and represented in three drawings in 1562 (fig. 69).

Figure 69. Bruegel.
TOWERS AND GATES OF AMSTERDAM.
1562.
Drawing, 7¼ × 12⅛".
Museum of Fine Arts, Boston.
Louis Curtis Fund

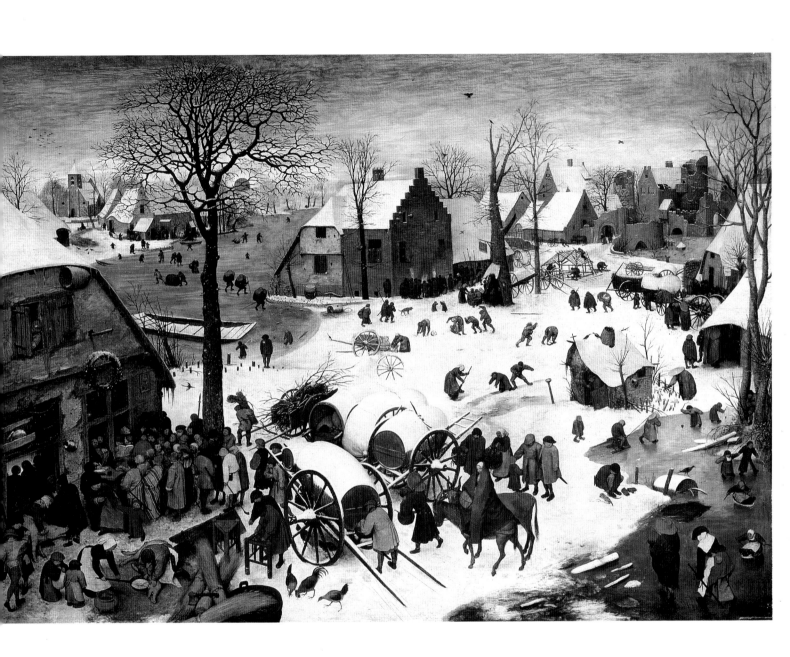

THE SERMON OF
SAINT JOHN THE BAPTIST

Signed and dated 1566
Panel, 37⅜ × 63¼"
Museum of Fine Arts, Budapest

The specific religious meaning of this painting has not yet been fully investigated. The subject as such was very popular; it occurs repeatedly in works by Bruegel's important predecessor in the field of religious scenes combined with landscape, Herri met de Bles (fig. 70). However, Bruegel introduced new details into it which give it a very special flavor. First of all, Christ is present here: He is recognizable by His unmistakable facial features, His light, almost radiant garb, His relative isolation, and by the left arm of the Baptist that points in His direction. Thus, Saint John's role as a mere forerunner of Christ is more palpably expressed than in most other representations of the subject, and the reaction of the people to his words is more immediately understood as reflecting their attitude toward the coming, or rather presence, of Christ as well. It is an attitude widely varying from deep thought, to mere staring, and to that of the enigmatic head appearing in the crowd on the left, with a wide-open mouth as round as his large blind eyes—a blind man aghast at seeing an inner light, or a yawning fool blind to the divine message? The actual presence of Christ can probably be considered Bruegel's approving comment on the importance of open-air sermons sponsored by reform-minded citizens all over the country, but it may be rash to see in it an approval of the members of the Reformed Church proper; although we do know that the latter were great propagators of open-air meetings—in which there was a great deal of satirical abuse of Catholic beliefs—it is quite possible that the circle of Erasmian, anti-clerical Catholics, with whom Bruegel was intimately connected, was also in favor of these gatherings as such.

A true enigma of this picture is the portrait of a gentleman who pays no attention to the sermon, but is having his fortune told by a gypsy in the very center of the foreground (in a direct vertical line with Christ!). To have one's fortune told was considered anathema by both the Old Church and the Reformers. It is true that almost the entire foreground is given over to enemies of Christ and the Baptist; the sinister conversation of the two men (Pharisees?) on the right, and the wait-and-see pose of the soldier fits into this pattern, which seems in turn to go well with Bruegel's generally pessimistic view of man. But why a portrait? And whose portrait? No patron could be expected to assume such a role, unless in deliberate self-deprecation. One could imagine Bruegel depicting himself as a sinner, but the features do not seem to be his.

Figure 70. Herri met de Bles.
SERMON OF SAINT JOHN. C. 1535–40.
Panel, 11¾ × 16½".
Cleveland Museum of Art.
Purchase, Andrew R. and Martha Holden Jennings Fund

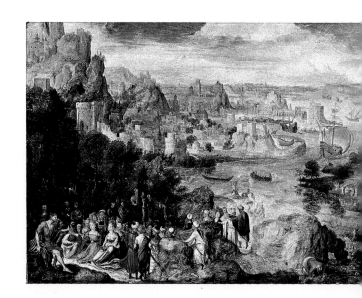

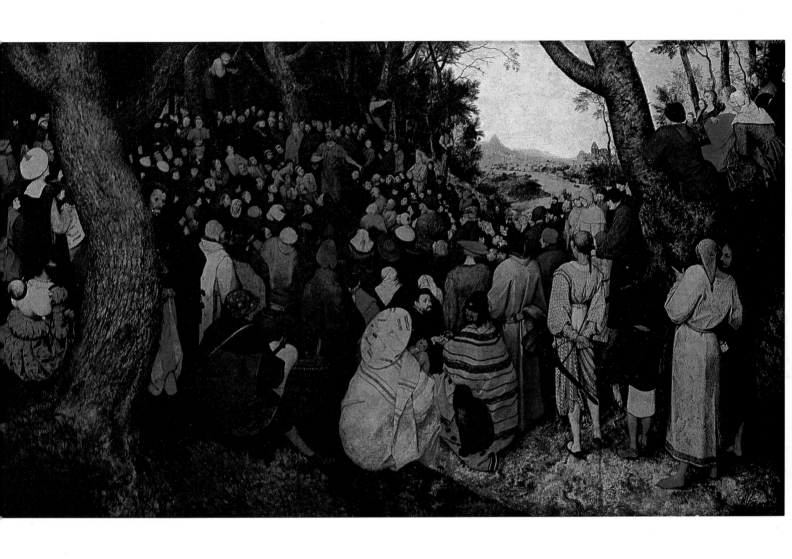

COLORPLATE 29

THE WEDDING DANCE

Dated 1566

Panel, 47 × 62"

Detroit Institute of Arts

The large Detroit panel is the first (in any case the earliest known to us in the original) of a splendid group with subjects that concentrate on the life and merriments of peasants, not in the sense of pure "genre" reports, but with a good deal of moral commentary mixed in. The wild abandon of this dance of the wedding guests is in itself such a commentary comparable to the characterization, a year or two later, of the guests at a wedding banquet (colorplate 33); in both cases the statement about the main protagonists is subdued, while that about the guests is pointed: they indulge in gluttony there, in lust here (its effect on the three men in front, previously bowdlerized through overpainting, has been restored only recently). The bride, who had been sitting under the crown in the far distance, is characterized by the wreath on her uncovered head, and is shown joining in a modest dance near the center of the picture with a rather elderly-looking man, perhaps her father rather than the groom, who may not have been admitted yet to the dance, at least not with the bride. But the front of this picture—which contains about 125 figures altogether—is defined by an abandon to human instincts with no regard whatever for the solemn aspects of a wedding. The turbulent rhythm, as well as the brilliant colors, mark the climactic stage of the movements; the color gamut is developed in a steady crescendo from background via middle ground to foreground; and yet the artist has given this wild display a sense of order in grouping and color relationships comparable to the firmness that a great composer can convey in even the most exciting of musical rhythms. The pairs in the foreground are swinging freely but in the most subtle interrelationships, and are contained by the postlike figures of the bagpipe player on the right and the onlooker on the left: variations on a theme between introduction and coda.

The detail, in spite of revealing evidence of damage to the surface of the painting, also testifies clearly to its authenticity. The underlying design shows repeatedly under larger areas of "local" color and may profitably be compared with the preliminary drawing for the two spectators of the Vienna *Calvary* in Rotterdam (fig. 58). The kissing couple is the direct predecessor of a similar one in the Vienna *Peasant Dance* (colorplate 34), but it has not reached quite the same weird joylessness. The lonely watcher at the right, too, has a somewhat less impassive face than his counterpart (in the left middle ground) in *The Peasant Dance* in Vienna; his smile has an enigmatic quality. The writing utensils hanging from his belt may indicate that he is an educated man who views the abandon of the peasants with an observing and perhaps skeptical mind rather than with sympathy or even condescendence. The musicians' postures and the movements of their hands are rendered with a wonderful combination of accuracy and sense of humor.

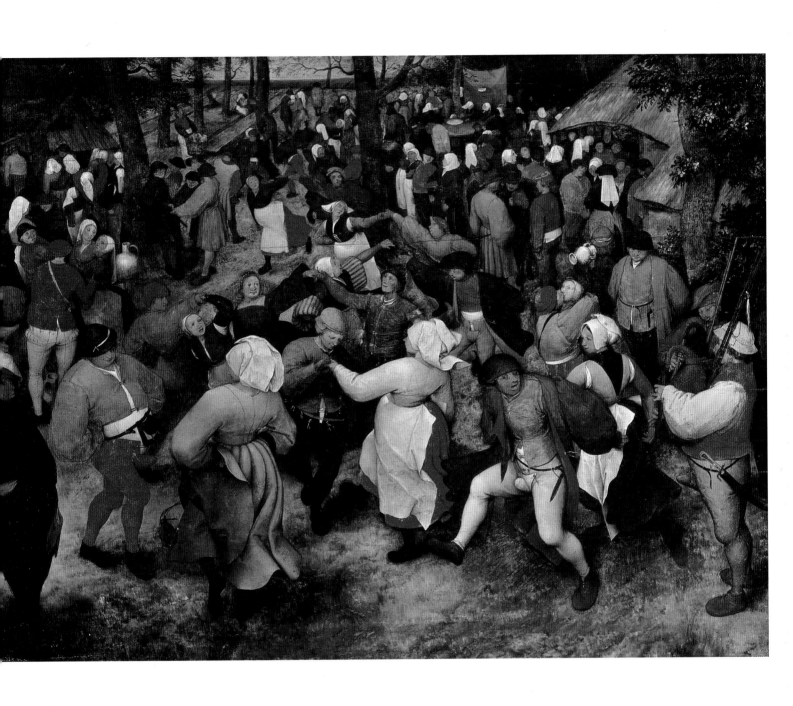

THE LAND OF COCKAIGNE

Signed and dated 1567
Panel, 20½ × 30¾"
Alte Pinakothek, Munich

This medium-sized work is the first of Bruegel's late paintings that contains only a few actors of large size—the beginning of his monumental *ultima maniera*. The subject (*Luilekkerland* in Netherlandish) was often treated in the popular literature of his time; it is closely related to the German *Schlaraffenland* which appears often in early sixteenth-century literature, and is also connected with the witch's hut in the fairy tale of Hansel and Gretel. In order to get to that country of free plenty, one has to eat one's way laboriously through what one might call a riceberg— a job just being finished off by the red and blue clad fellow in the right background of Bruegel's picture. No work is necessary after that; you lie down, and food will either run about in a frantic effort to get consumed, or will glide down from above straight into your mouth. The clientele of this utopia was visualized by Bruegel in terms of people of various professions that, taken together, stand for Elck, Everyone; but it is characteristic of his late style that there is now a rigorous selection of four such representatives instead of a host of them. The knight has chosen to sit by himself under a roof from which pancakes will automatically slide into his mouth. But soldier, peasant, and clerk—each characterized by his costume and by an appropriate attribute: lance, threshing flails, and writing utensils—have become the spokes of that weird wheel of laziness and gluttony which has stopped rotating for want of momentum. The bellies, backs, legs, heads, table, egg, pancakes—all are round; and so is the very piece of earth on which everything and everyone weigh down relentlessly. There is no air, no relief from stuffing anywhere; the full stomach reigns supreme and as though for eternity.

The relationship between Bruegel's painting and an engraving of the same subject by Pieter Baltens,

signed with the monogram PB (fig. 71), is not entirely clear. It has been assumed that the latter is a derivation from the former; but a recently discovered document indicating that Baltens worked in a superior position alongside Bruegel in 1551 may make a revision of this theory necessary. Baltens' print does show the central "spoke"-rotation (though with six instead of three persons) with which one is tempted to credit Bruegel; on the other hand it is hard to see why the designer of the print would have willingly deleted so many of Bruegel's most impressive features. An exact reproduction (in reverse) of Bruegel's painting was made in an engraving, unfortunately anonymously, and without date, but certainly not very long after Bruegel's death. This is a rare case; only extremely few of the master's paintings were reproduced at that time.

Figure 71. Pieter Baltens.
THE LAND OF COCKAIGNE. After 1567(?).
Engraving, 8¾ × 12"

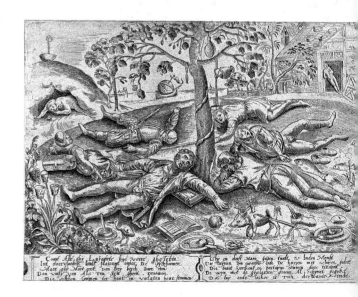

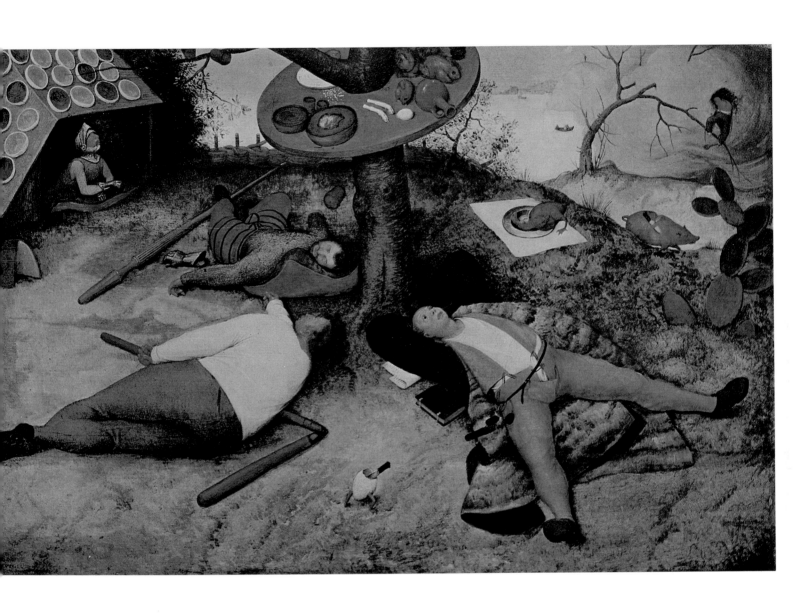

COLORPLATE 31

THE CONVERSION OF SAUL

Signed and dated 1567
Panel, 42½ × 61⅜″
Kunsthistorisches Museum, Vienna

The subject of this picture was extremely popular with sixteenth-century artists everywhere. In Italy, Michelangelo's fresco in the Pauline Chapel of the Vatican (1542–45; fig. 72) was producing a vast Mannerist progeny at the time when Bruegel painted his picture, and in all of them, the prominent figure of the smitten Saul was more or less the center of attention (although never in the grandiose isolation which Caravaggio was to discover as the core of the story in 1600). Bruegel's subject is not so much that fall as the "Road to Damascus," and in arriving at this novel interpretation he fused a great personal insight with a widespread Mannerist convention, namely the pushing back of what is normally considered the main subject of a composition into its background. It is true that the fall of Saul—who is rendered as a rough, bearded captain, not in any way a potential saint—is found not too far from the center of the picture, as Christ was in *The Procession to Calvary*, and that his blue uniform makes him stand out a bit more prominently than does his (not fully isolated) position on the ground; but he is separated by a vast distance from the ray of light in which the "voice" of Christ is clad, and whose impact on the scene is more clearly intimated by the pose of Saul's groom than by illumination proper. The basis of the picture is the transformation of the story about sudden conversion into the pictorial equivalent of the long and arduous road to truth. The Bible (Acts 9:3 ff.) says nothing about the physical properties of that road; for Bruegel it became the very epitome of a difficult and seemingly endless ascent along and through the most forbidding Alpine cliffs and gorges. The start, in the left distance, is lost in a haze which spreads over a vast plain; the end seems to be nowhere in sight on the upper right, where a huge army winds its way between steep rocks under threatening skies. At the lower right, a dappled horse and its rider clad in yellow and red summarize the direction of the entire trek in one symbolic curve; the necessary stabilizing factor—retarding only insofar as it calls attention to the fall—is provided by the central massif and the magnificent dark cypresses in front of it, as well as by the horseman seen directly from behind and the standard at the extreme right.

Figure 72. Michelangelo.
CONVERSION OF SAUL. 1542–45.
Fresco, 20′ 4″ × 22′.
Pauline Chapel, Vatican, Rome

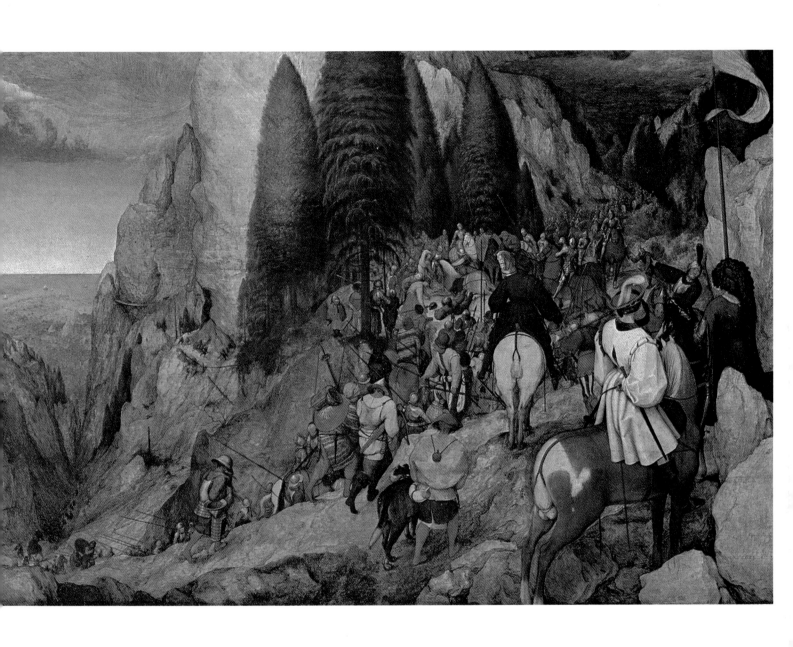

THE ADORATION OF
THE KINGS IN THE SNOW

Signed and dated 1567
Panel, 13¾ × 21⅝"
Collection Oskar Reinhart, Römerholz, Winterthur

The date on this small signed painting is not quite distinct but ought most probably to be read as 1567. The picture differs fundamentally from Bruegel's two large, earlier representations of the same subject, the canvas in Brussels (fig. 60) and the panel of 1564 in London (colorplate 18); it rather looks like a follower of the (much larger) *Census at Bethlehem* of 1566 (colorplate 27) in that the Biblical story is now subordinated to the interpretation of a "Winter Day in a Flemish Village." This aspect has been emphasized by the introduction of the extraordinary motif of the actual snowfall, which does appear in some fifteenth-century book illuminations, but not in connection with the *Adoration of the Magi* (after Bruegel it survives as a sheer genre motif with Lucas van Valckenborgh—fig. 73—and later with Aert van der Neer). The

Bethlehem hut, quite comparable with some buildings in the Bethlehem of the 1566 *Census*, particularly the hut with the cross on its gable which we suspected of intimating the hut of the birth, rises at the left; barely sheltered from the snowfall, Mary presents the Child to the Magi, two of whom kneel before her; Joseph keeps in the background. From there to the gate in the right background, the snowy road is filled with the retinue of the Magi and their pack animals; inhabitants of the village trudge along other roads and busy themselves with everyday tasks. The large building on the right continues the age-old architectural symbolism of Nativities and Adorations of the Magi: it clearly suggests a Romanesque church and, with its window with three openings, the presence of the Trinity.

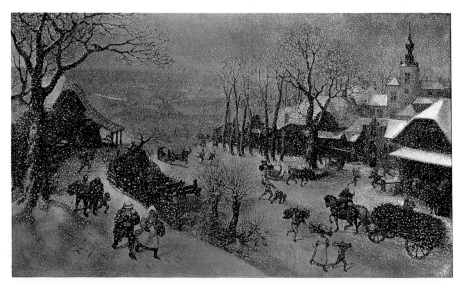

Figure 73. Lucas van Valckenborgh.
SNOWFALL IN A VILLAGE (DECEMBER).
1586. Canvas, 46 × 77⅞".
Kunsthistorisches Museum, Vienna

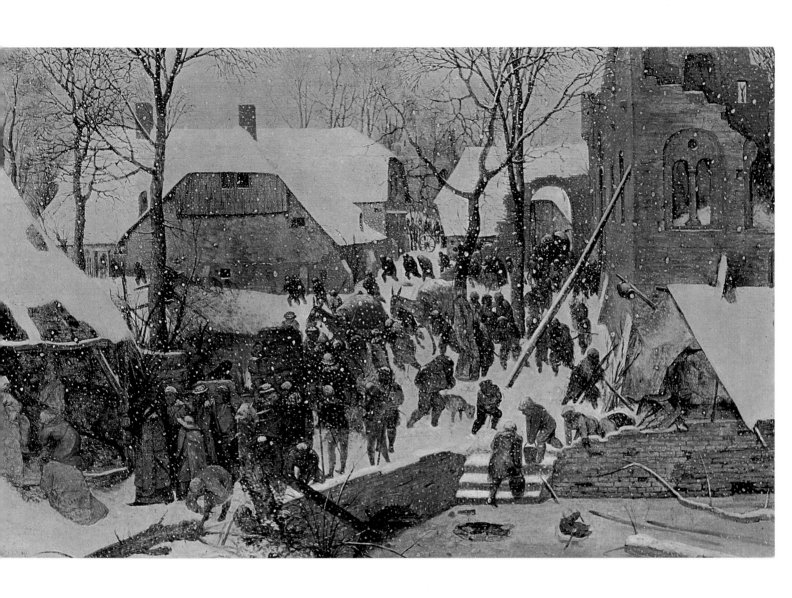

THE WEDDING BANQUET

Datable 1567 or 1568
Panel, 44⅞ × 64⅛"
Kunsthistorisches Museum, Vienna

The signature and date of this picture were probably lost with a small bottom strip of the panel which was later replaced; the probable year of its origin is 1567 or 1568. No painting by Bruegel has been discussed more fully than this as far as the subject is concerned; some progress in this field has been made, but it would be foolhardy to maintain that a generally accepted solution has been found. That a wedding banquet is represented cannot be doubtful; to the right of the center, though rather far away from the viewer, the plump smiling bride, her hands somewhat sheepishly folded, a wreath on her hair, sits under a primitive crown in front of a rug hung from the wall. It has often been maintained that in this picture the groom is missing, and much acumen has been spent on possible explanations of this phenomenon. But this view is open to doubt. Much more pertinent is the more recent observation that the groom, provided he was admitted at all to a banquet in the house of the bride's parents (who are present here), was expected to *serve* the bride and her family on that occasion. If this is accepted, he can most probably be identified with the modest youth who—quite inconspicuously— takes dishes from the door plank carried by the two burly servants in the right foreground and passes them on to the table in the direction of the bride.

But there is an unmistakable satirical point to this entire scene, and this is epitomized by the child sitting in front, absorbed to a degree of self-"effacement" in licking his fingers, and by the man refilling a seemingly endless number of wine pitchers. The latter motif was popular in representations of the *Wedding at Cana*, with which this painting shares a few other features; but if Bruegel wanted to evoke the memory of this cherished example of Christ's miracles, he certainly did so in such a way as to brand the present proceedings as a perversion of a sacred rite, dominated by gluttony rather than the solemnity of the hour. Wine and food are all these people care about, either in consuming them—everyone at the table except the bride, her parents, the groom, and the two special guests!—or in providing them—the groom and the servants in front. The musicians chime in or stare in the direction of the food bearers in anticipation. None of the guests seems to give one thought to the spiritual meaning of the occasion in the true tradition of the *Wedding at Cana* or, for that matter, the tradition of *The Last Supper*, which under Tintoretto's hands was later to take on a somewhat comparable form. Is this callousness what the Franciscan monk complains about to the bearded gentleman, who listens to him, his hands folded, at the extreme right of the picture?

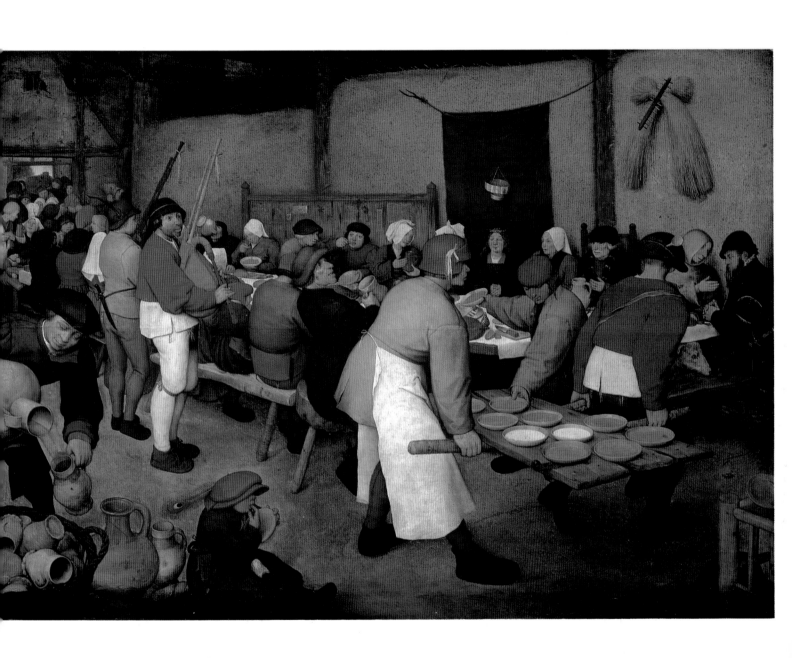

THE PEASANT DANCE

Signed; datable 1567 or 1568
Panel, 44⅞ × 64½″
Kunsthistorisches Museum, Vienna

The Peasant Dance, although signed, is not dated; however there can be no doubt that it belongs in the closest neighborhood of the Vienna *Wedding Banquet* (colorplate 33), which is of exactly the same size; both must be placed in the year 1567 or 1568 for cogent stylistic reasons.

The Wedding Dance in Detroit of 1566 (colorplate 29) had already defined Bruegel's attitude toward an excess of dancing on a solemn occasion: it is sinful and, like all sin, foolish. His opinion did not change as he contemplated man's folly on what must be a saint's day, probably even one connected with the veneration of the Mother of God. A tiny image of Mary (perhaps a cheap colored woodcut?) is affixed to the tree at the right, above a pot with a few flowers which, neglected, is about to fall down; the church lies abandoned in the background; the one really prominent building is the tavern, that "devil's schoolhouse," on the left side; its huge flag dwarfs the Madonna picture manifold; a woman is about to pull a man into its door.

The foreground is given over to dancing, music, eating, drinking, and kissing. However, the main couple, on the right, is not dancing yet. The man, quite a disagreeable character, elderly and with a grimacing face, is pulling a very stupid-looking matron into the picture without so much as turning to her; one may compare this with the joyful countenances and intimate interrelation of the bodies in Dürer's famous engraving, *The Peasant Dance* of 1514, to which Bruegel may have been indebted for the rhythmic pattern of other dancers, and which anticipated the heavy clumping of Bruegel's figures. "As the old sing so the young whistle": two children, tiny but old-looking and old-acting like so many of Bruegel's children, are already at it on the left. The grotesque-looking bagpipe player has to provide all of the music by himself; he is sustained by a young peasant who has brought him a big pitcher and who rather conspicuously wears a peacock feather on his cap; this feather surely stands for the sin of vainglory, and it is tempting to see the nutshells on the ground as symbolizing those who abandon their highest good, salvation, "for a hazelnut," just as the *Two Monkeys* (colorplate 13) had abandoned theirs, freedom, for the same fare (the prominent bare bone [?] probably contains a similar allusion). At the table, eating and drinking is the main point of the festival day; it looks as though two men were laying a wager, and the agitated faces near them were intimating an ensuing fight: the young peasant lays his left hand on the shoulder of the older man with the blue cap in an apparent attempt to restrain him from making the bet. Behind them a couple unites in a strangely joyless kiss; to their right stands a lonely young man vaguely looking at the dance, the counterpart of the more prominent "loner" of the Detroit *Wedding Dance* (colorplate 29). The couples in the middle ground perform their dances with abandon, and yet even here one misses the expression of joy which is written all over Dürer's two faces; there are no smiles here. The houses are handsome, the whole place is affluent, the trees are in foliage, the lonely church is in good repair; but nature is not a redeeming factor here, and the village street is as totally dominated by man's folly as is the room of *The Wedding Banquet*.

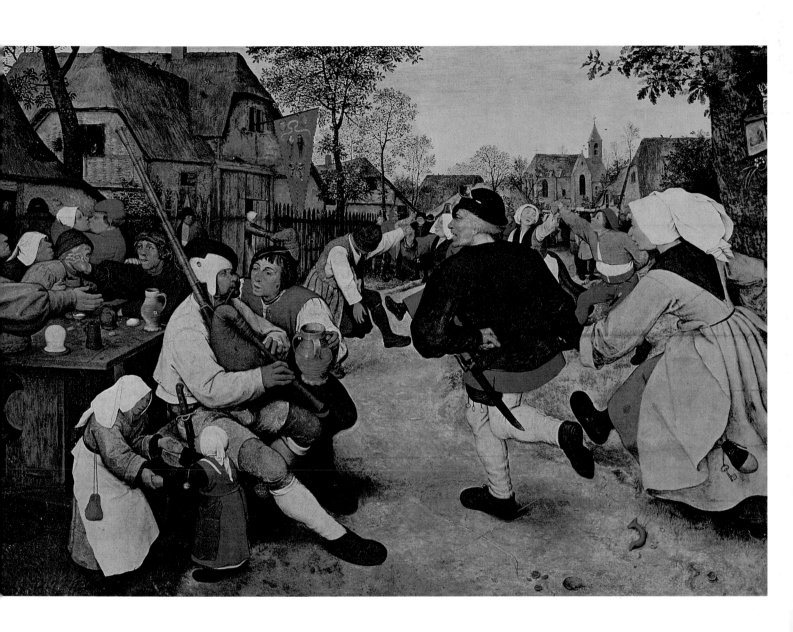

THE MISANTHROPE

Signed and dated 1568

Canvas, 33⅞ × 33½"

Museo Nazionale di Capodimonte, Naples

The Misanthrope, The Parable of the Blind of the same year (and with the same provenance), and the early *Adoration of the Kings* in Brussels (fig. 60) are the only preserved works by Bruegel that were painted by him on canvas, in a tradition he absorbed during his early training at Mechelen. It is the only late painting by Bruegel in which he reverted to the use of the kind of "absurd" symbolism that was part of the Boschian heritage; its round form, unique with Bruegel, likewise points to Bosch. And it is also the only example of a beautifully lettered, literary explanation found on any *painting* by the master, and with that, harks back to the custom observed in some of his earlier designs for prints—a custom he may also have revived in *The Beekeepers*, a drawing probably made in 1568 (fig. 74).

"Because the world is so unfaithful—That is why I go in mourning." The world is represented by a perfidious purse snatcher "dressed" in a globe which makes him stand for the world; and this world is here *not* characterized as a topsy-turvy world, with the cross down, as it appears (twice) in the *Proverbs* of 1559, since the point here is not folly but wickedness, which includes the abuse of a potentially sacred symbol. The purse is red (perhaps symbolic· of sin here), the dress of world, lilac and light blue; they contrast vividly with the deep blue of the hermit. The faithful shepherd in the background is placed, as an eloquent contrast, above the round piece of mischief that stands for the world.

The shepherd of this picture is the exact opposite of the main figure in what must have been a superb painting by Bruegel, *The Unfaithful Shepherd*, now available to us only in a copy or possibly a much over-painted original in Philadelphia. As a wolf scatters his flock, this shepherd runs away toward the spectator, almost piercing the picture plane with his staff; but he conveys the expression only of flight, not of fright: his face is void of any character, bland rather than fearful; he "could not care less" for his flock. The faithful and the unfaithful shepherds, the former defending his sheep against the wolf, the latter running away, had already been contrasted with each other in the spandrels of Bruegel's composition of *Christ as the Good Shepherd*, engraved by Philip Galle in 1565.

The landscapes of both the Naples and the Philadelphia pictures are enchanting and, in spite of reminiscences of Hieronymus Bosch, immensely precocious. Their horizons, however, still lie high, although in other works of this period, such as *The Peasant and the Bird-Nester* (colorplate 37), it has been lowered to a more "normal" position—which indicates once more that merely formal phenomena of this kind cannot be used as criteria of "development" in Bruegel's works.

But is the title "The Misanthrope" well chosen? That depends on whether one interprets this as a depiction of a momentary action, or as a composite of two actions. If the purse snatching is a past experience of the old man which prompted him to seek solitude and to dress in mourning, the title may stand, and in any case, he still faces the prospect of stepping on one of the caltrops which lies on the ground before him. If he carries a (potentially well-hidden) purse with him *into* his seclusion we cannot be so sure; he would then appear to be a greedy miser and a blatant hypocrite at the same time, and the words he is pronouncing would be highly suspect since his own action would be "unfaithful." It is to be feared that the second alternative is the more probable one and that the round shape encompassing the old man, far from having been chosen for purely formal reasons, puts him in the same dubious position as the "unfaithful world" itself.

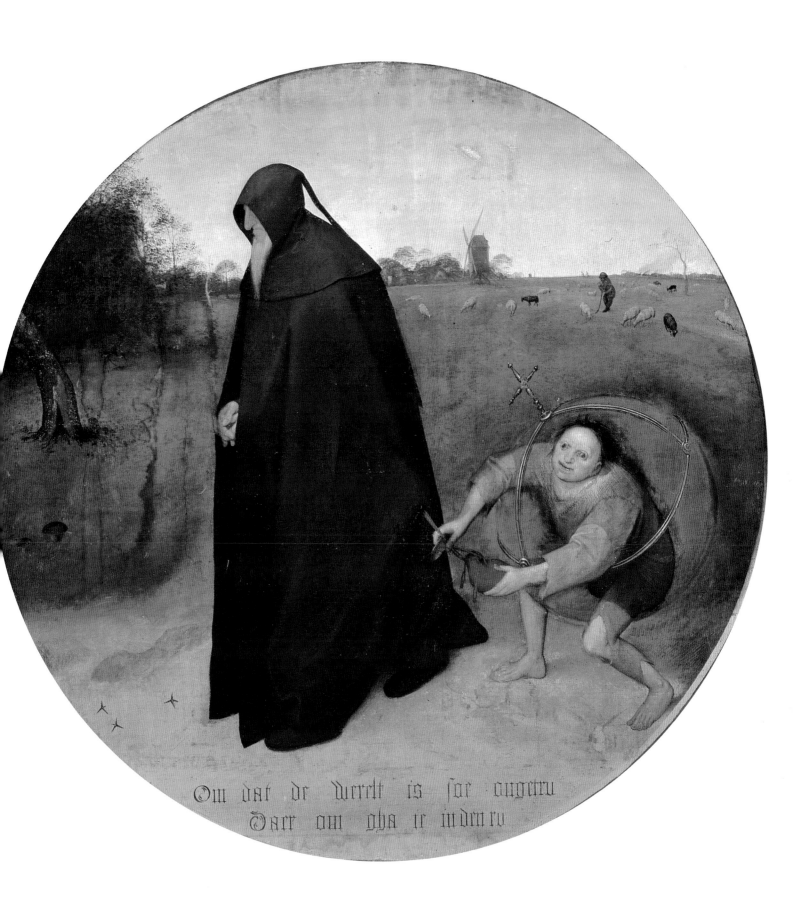

Om dat de werelt is soe ongetru
Daer om gha ic in den ru

THE PARABLE OF
THE BLIND

Signed and dated 1568
Canvas, 33⅞ × 60⅝″
Museo Nazionale di Capodimonte, Naples

With *The Misanthrope* of the same year, which is also painted on canvas in a late revival of the technique Bruegel had learned in Mechelen in his youth, this large painting shares the special reticence toward strong colors and the preference for delicate tints such as mauve, gray, a subdued green, and dun.

The subject chosen by Bruegel for this consummate masterpiece is a parable of Christ (Matthew 15:14): "If the blind lead the blind, both shall fall into the ditch." It appears as one among a host of proverbs in the Berlin panel of 1559, far away in the background (colorplate 5); now it is singled out for a large composition of overwhelming power. Its isolation as such had been anticipated in a design which was attributed to Hieronymus Bosch in the engraving to which we owe our only knowledge of it.

The inevitable fall is expressed by the one great descending diagonal of the victims' heads and arms sustained throughout the picture, and underlined by parallel and reinforcing diagonals in their staffs and in the sloping ground. The weaker counteracting diagonals, necessary for a formal equilibrium even in the most expressively constructed compositions, are provided by the slanting bodies themselves, the second staff from the left, and the pathetic little bare shrub at the lower left. No less important in producing the impression of a hopeless fall are the vertical and horizontal lines in the background, provided by the meadow, the gently curving hill, the trees, and the church; they mark the necessary contrasts to the diagonals, while the conical forms of the houses on the left support the development of the diagonals in the procession which issues from them. But there is more. A straight, uninterrupted diagonal would not only be dull and pedantic from the point of view of form, but would also miss the tension, the breathtaking drama the story contains. While the leader already lies prostrate in the ditch and the one next

to him is clearly doomed, there seems to appear a flickering ray of hope for the rest, expressed by an interval without fall—an interval which for a moment even seems to receive sanction by the contrasting, sturdy vertical of the church. But the fourfold forward bend of the men approaching from the left destroys that futile hope, and the pathetic upward tilt of the heads of the leading men of that group reminds us—rather conveys to us optically—that, being blind, they cannot even fathom what is going on in front, and are therefore destined to share the fate of their leaders. Whether that failure of the church building to stop the catastrophe of the miserable procession can be considered to have had a symbolic meaning for Bruegel and his friends must remain an open question.

We are all likely to "read" this painting as the unsurpassed depiction of a *tragic* event, and we cannot conceivably be wrong about this: we only have to look at the faces of these men. It is true that the people of Bruegel's time were not much moved to pity by the sight of cripples (see p. 124), and blind people can be assumed to have been put in the same category. The extraordinary blind man in Bruegel's own painting with *The Sermon of Saint John* (colorplate 28) has not yielded his secret yet. But in *The Parable of the Blind*, all these pathetic men are, as in the Bible, *victims*. Christ saw the *Pharisees* as "blind leaders of the blind," and it would have been possible to depict this story in terms of a group of innocent victims of a vicious and irresponsible leader. Neither Bruegel nor Bosch did so; in their accounts, the leading men are not evil, but unhappy people, just as are the others (and Christ might have agreed). But it is only in Bruegel's interpretation that *all* men's forsakenness (*der Menschheit ganzer Jammer*) is seen in the image of the blind who have no leader at all.

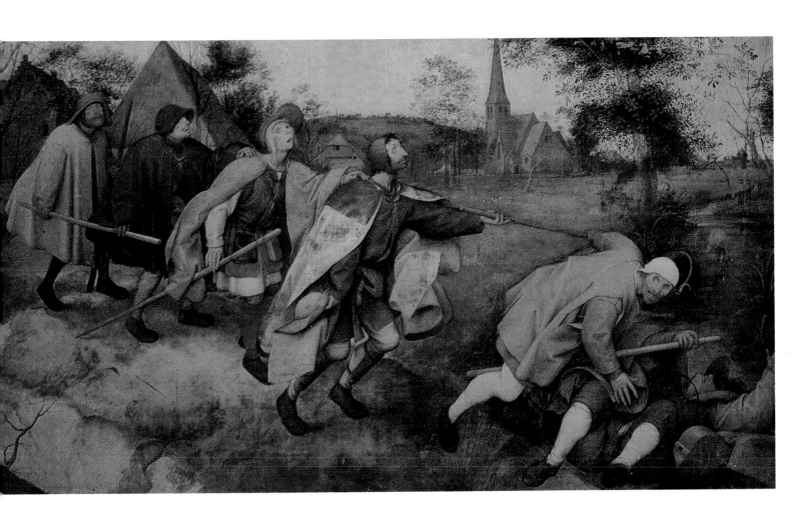

THE PEASANT
AND THE BIRD-NESTER

Signed and dated 1568
Panel, 23¼ × 26¾"
Kunsthistorisches Museum, Vienna

The deepest meaning of this medium-sized picture has probably not yet been unearthed, but it can be considered certain that it is based on the Netherlandish proverb which proclaims that "he who knows where the nest is has the knowledge, he who robs it has the nest." The huge, decidedly Michelangelesque peasant, who in something like a perversion of customary Mannerist procedure, seems to walk right out of the picture toward us and to address us more directly than does any other figure in Bruegel's works, summarizes this insight; he knows where the nest is—he can point it out to us without looking back—but he is hardly in a state to get it, whereas the boy snatches it at the merely temporary cost of his hat. That the peasant, an amiable man with a somewhat blank face, represents some kind of virtue here is hardly doubtful; the prominent bramble at the left was possibly added as a symbol of a person overcoming temptation. But virtue does not always pay, and perhaps Bruegel emphasizes here that *self-righteousness* does not: the good man, busy explaining the situation to us, forgets to watch his step and is about

to fall into the creek which separates us from him, making him "all wet"; he also seems to have lost his bundle (in David Vinckboons' engraved illustration of the same proverb another boy steals his purse). It is perhaps just possible that Bruegel wanted to suggest something else as well, namely that the peasant felt he was *clever* by not risking his limbs for the sake of the nest, and points out to us the folly of the boy in doing so. In any case, Bruegel's pessimistic interpretation appears in very similar form in a drawing probably made in the same year (fig. 74): here three beekeepers make elaborate but futile preparations for the catching of a swarm, literally blinded to the fact that a boy has climbed a tree and already stolen their prize. There is some doubt as to whether the inscription on the lower left is Bruegel's own; but even if it is by a later hand, it fits the situation perfectly since it is nothing else but the proverb quoted above for the *Bird-Nester*—the appropriate adaptation to the bee's swarm is left to the observer. The plant in the foreground here refers to the thief rather than the anonymous faceless victims; it is a mandragora, a "gallow's child," and hints either at the thief's origin or at his destination.

The Peasant and the Bird-Nester, like the other paintings of the same year, glories in a landscape of extraordinary beauty. It fully embraces both figures, and its delicate forms and tints make a perfect contrast with the heavy shape of the peasant, and the large, nearly unbroken color areas of his clothes.

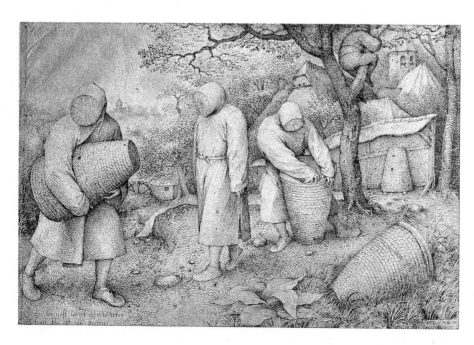

Figure 74. Bruegel.
THE BEEKEEPERS
AND THE BIRD-NESTER.
1568(?)
Drawing, 8 × 12¼".
Kupferstichkabinett,
Staatliche Museen, Berlin

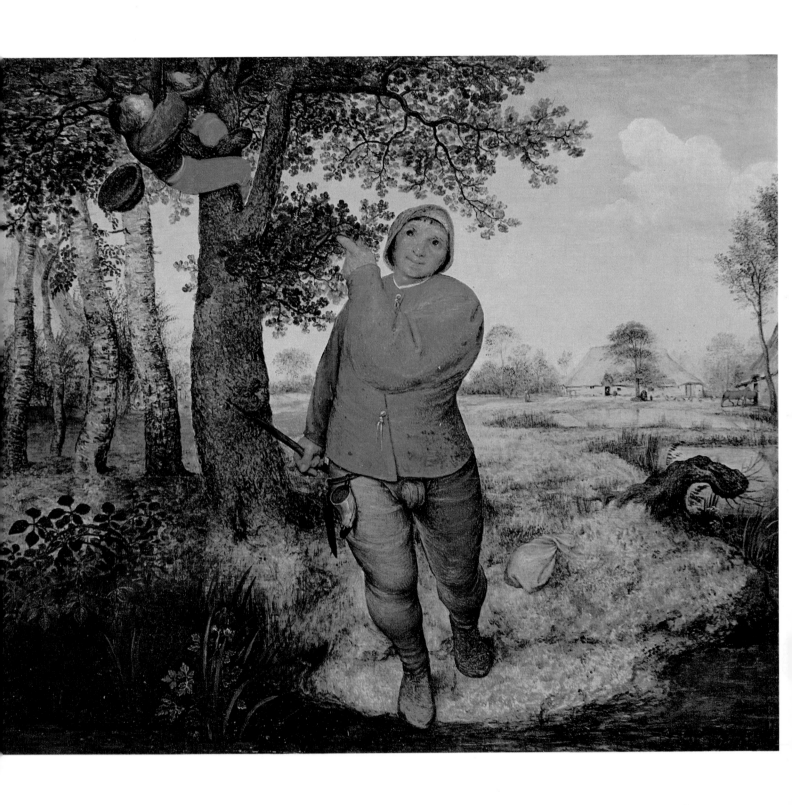

LANDSCAPE WITH THE MAGPIE
ON THE GALLOWS

Signed and dated 1568
Panel, 18⅛ × 20"
Museum, Darmstadt

Carel van Mander (1604) mentioned this picture as having been bequeathed by Bruegel to his widow with the information that with the magpie he had alluded to the gossips whom he assigned to the gallows. To "babble like a magpie" is indeed an old Netherlandish expression, and so is the one that speaks of "gossiping [somebody] on the gallows," i.e., causing a person to be hanged by gossiping about him. Since the Netherlandish form of the latter version can also be understood as "[somebody] gossiping on the gallows," the magpie *sitting* here on the gallows may well have been intended as a pun. A second magpie is sitting on a tree trunk in the foreground; the Netherlandish word for trunk can also mean the stocks (pillory) on which gossip may easily land somebody. One of the two peasants standing in the left foreground points to the gallows (probably to the magpie), underlining the picture's meaning; on the right, a water mill is much in evidence, and water mills were considered another simile of gossiping. Like gossiping on the gallows, "dancing on the gallows" is an ambiguous expression, and can mean causing somebody to hang on the gallows as well as dancing near the gallows, as here represented by Bruegel; the reason for someone's hanging on the gallows can of course again be gossip, thus making the magpie indeed the very core of the meaning of the picture just as its location is in the exact formal center of the picture. As far as truth is concerned, gossip is worthless talk; it is "shit," as the man in

the left corner indicates; but its results can be as sinister as poison's. Van Mander may very well have had reliable information concerning Bruegel's intentions, the more so as he alludes in the same passage to certain works which Bruegel, on his deathbed, commanded his wife to destroy; gossip could have made them appear more damning in the eyes of the authorities than the artist intended them to be, and later interpretations, including some very recent ones, have borne him out on that point.

As in other late works by Bruegel that combine allegory with prominent landscape (*The Misanthrope, The Parable of the Blind, The Peasant and the Bird-Nester,* all of the same year; colorplates 35–37), nature is the very opposite of human stupidity and sin: radiant, serene, God's own—and here even more so. It occupies a much larger area than in those other works, restricting man to a much smaller size, and thus points to a Bruegel reverting to the great landscapes of the "Months" of 1565, and even earlier works. But the balance between compositional grandeur and miniature-like wealth of detail is superior here to anything that Bruegel has given us before; colors scintillate, there is an almost pointillistic touch to the fresh foliage throughout, and the rendering of the infinitely small joins with the suggestion of infinite space in a vision which might have resulted in an entirely new style had Bruegel lived even a few years longer.

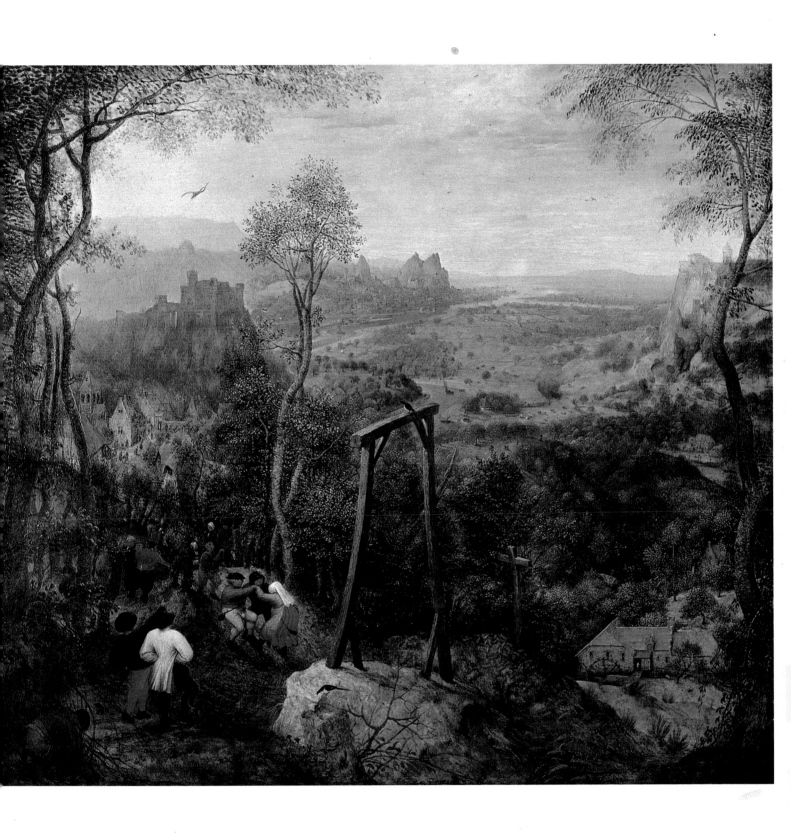

THE CRIPPLES

Signed and dated 1568
Panel, 7⅛ × 8½"
The Louvre, Paris

The Cripples is the smallest extant work by Bruegel and may therefore suggest a rather personal, intimate origin, as does the picture of the *Two Monkeys* of 1562 (colorplate 13). Its subject was an almost complete enigma until recently, when the foxtails worn by these men were convincingly identified as the emblems of lepers, displayed during their customary procession on the Monday after Twelfth Night and the days of Carnival. But this is no procession; nor is one reminded, except for details, of the loose assemblage of such people in the Vienna *Fight Between Carnival and Lent* of 1559 (colorplate 3). The five victims of the dread disease are united in a group of monumental grandeur placed in what looks like the courtyard of a hospital. An old woman, presumably a nurse, wanders off to the right, a bowl in her hand, but she has brought no food to the cripples who do nothing in particular; one seems to be complaining loudly, two are conversing, two others turn their backs to the spectator, one toward the departing woman, the other toward the distant gateway which may stand for unobtainable health and freedom.

One must beware of the danger of interpreting such an accumulation of physical defects in modern terms of sympathy and pity. Two famous drawings with beggars and cripples in Vienna and Brussels may go back to Bruegel rather than to Hieronymus Bosch, to whom they are often attributed on the basis of the inscription of a sixteenth-century engraving after the former; be that as it may, that engraving contains a legend which is anything but sympathetic to its wretched subject. Couples of cripples engaged in

mock dances appear in powerful prints by Cornelis Massys in 1538. The tendency to identify bodily with moral defects was very strong (as it still is in many places today); that the cripple was likely to be a scoundrel was a widely accepted belief in the sixteenth century.

Bruegel did not compose this magnificent group in order to promote the cause of the unfortunate ones; the faces (and even the non-faces) exclude that possibility. The host of political allegories variously suggested for this picture must likewise be abandoned, even though foxtails have occasionally been used in political satire. The true *raison d'être* of the picture remains obscure. Its incomparable power rests on its synthesis of factual truth and structural strength which lifts it far above the level of the first occurrence of the subject in the panel of 1559, just as the Naples *Parable of the Blind* of the same year, 1568, towers over the first occurrence of its subject in the *Proverbs* of 1559. The broad modeling of form suggests the knife of a woodcutter, applied to human blocks that are endowed with a remarkable resistance to weather; one feels that these wrecks could outlast many whole men of more delicate fiber.

The picture bears on its reverse an inscription consisting of a few only partly legible Netherlandish words and two Latin distichs. It would not be surprising to find that these verses were either the work of Bruegel's friend and admirer Abraham Ortelius, who expressed himself in similar terms on Bruegel's art in his epitaph, or of a friend of his. Was this small panel a gift of the artist to Ortelius?

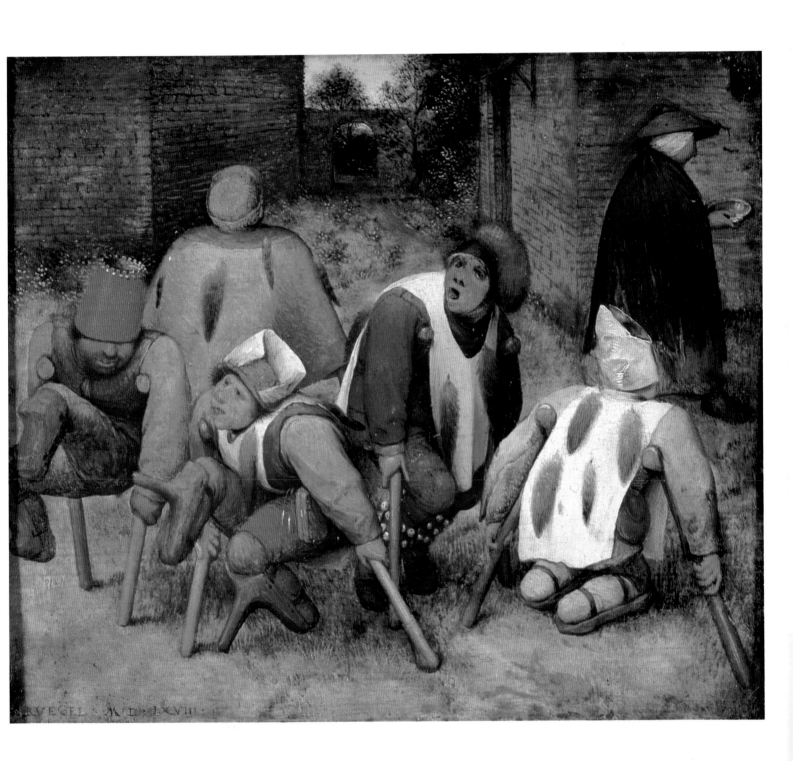

COLORPLATE 40

THE STORM AT SEA

Datable 1568 or 1569
Panel, 27⅝ × 38¼"
Kunsthistorisches Museum, Vienna

This unfinished painting is neither signed nor dated, and its attribution to Bruegel is still disputed by some. If it is a work by Bruegel—of which this writer is firmly persuaded—it may very well have been left unfinished because of the artist's death, for it seems to fit his *ultima maniera* as convincingly as the *Ravens Flying over Cornfields* fits Van Gogh's. The attribution to Joos de Momper, which first appeared in the late nineteenth century and was later revived occasionally, is not borne out by recent studies of that master, and seems to underrate the profound symbolism of this work as much as it does its artistic level.

In the frightening darkness of the turbulent sea, seen from above as in the *View of Naples* (which, however, now seems miniature-like in comparison; colorplate 8), the artist has delineated an even more frightening triangular area of sharp green in which the most important elements of the composition are assembled: the ship in distress, the barrel, and the monstrous whale with its gaping red gorge. The

meaning here is clear (cf. Swift's *A Tale of a Tub*) and can be traced in literature to a period close to Bruegel's (Olaus Magnus, 1539), and even before: the throwing out of a barrel, far from being just a means of shedding ballast, is designed to make the whale play with it and thus to gain time to escape; the green area is the result of the castoreum which the sailors, according to Olaus Magnus, poured on the waves to frighten the whale. But Bruegel seems to have been the first to view the propensity of the whale to play with the barrel as a parallel to the stupidity often shown by man in pursuing worthless trifles instead of valuable goals. In this fashion, the whale, like the two monkeys selling their liberty for a hazelnut (colorplate 13), became a simile of man's folly; but at the same time, this interpretation is overlaid, as it were, by another which connects the fate of man with the crew of the ship that has a chance of being saved from peril by renouncing some material goods, and of escaping to the safety symbolized by the church rising on the horizon under a clearing sky. Such double symbolism is as plausible in a late work by Bruegel as it is far beyond the spiritual means of an imitator, and the same appears to hold for the magnificent sweep and unity of the formal organization of this great torso.

The drawing with a *View of Antwerp from the Sea* (fig. 75), Bruegel's only preserved marine drawing proper, seems to have helped to prepare the way for this painting.

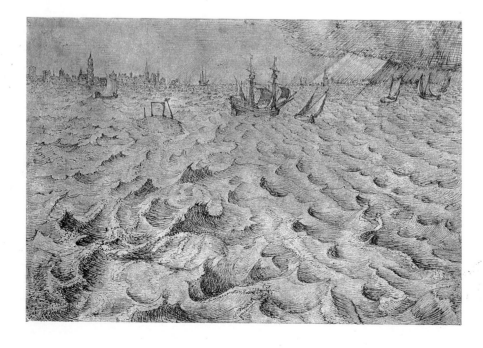

Figure 75. Bruegel.
VIEW OF ANTWERP
FROM THE SEA.
c. 1565.
Drawing, 7⅞ × 11¾".
Collection Count Antoine Seilern,
London

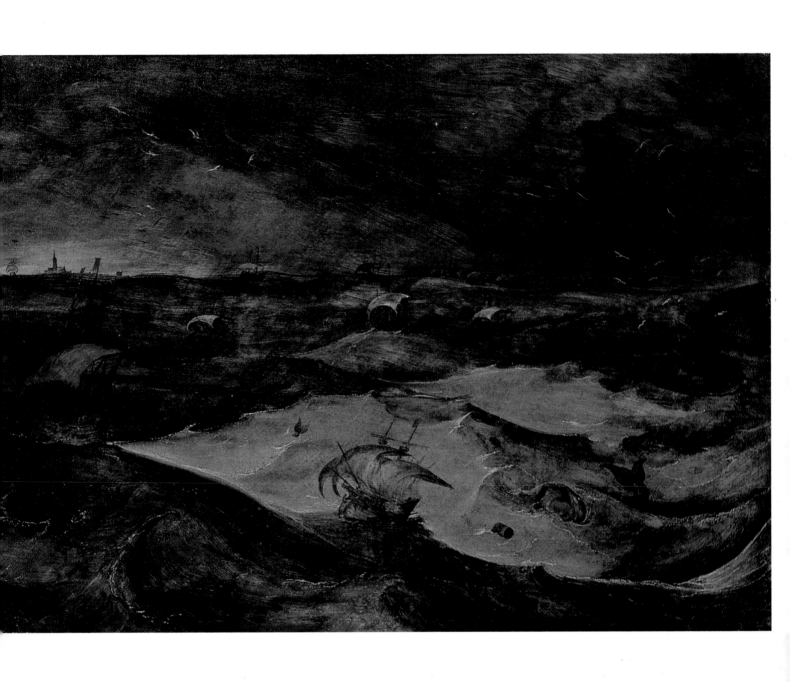